'It is absurd to divide people between good or bad. People are either charming or tedious.'

— Oscar Wilde

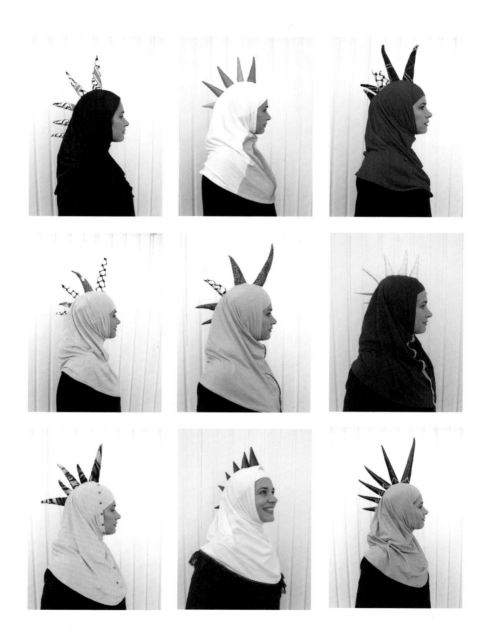

Shadi Alzaqzouq: MUSLIM PANIK PERFORMANCE
Stylist: Hélène Roy

DON'T PANIC, I'M ISLAMIC

WORDS AND PICTURES ON HOW TO STOP WORRYING AND LEARN TO LOVE THE ALIEN NEXT DOOR

EDITED BY LYNN GASPARD

SAQI

CONTENTS

'Our country needs strong borders and extreme vetting, NOW. Look what is happening all over Europe and, indeed, the world – a horrible mess!'

8:08 AM, 29 JAN 2017

@realDonaldTrump

A personal guide to extreme vetting: how to distinguish an acceptable Arab from a terrorist in 6 easy steps

ARWA MAHDAWI

Say what you like about Donald Trump, you've got to admit that he tells it like it is. His directness of expression is unpresidented in the White House. He's a real American and he talks real American.

Which is why Trump's obsession with 'extreme vetting' is troubling. Not only is extreme vetting a multi-syllabic phrase, it lacks the compelling comprehensibility that characterises Trump's other policies, like 'build a wall' or 'lock her up'. I'm afraid to say that it smacks of politicking. After all, what does 'extreme vetting' actually mean? Judging by the amount of debate the term has provoked, nobody is entirely sure.

The ambiguity of extreme vetting has been cause for consternation in some quarters. Progressives, in particular, have done much fretting about extreme vetting. Many have argued that it is nothing more than thinly-veiled Islamophobia; that Trump is trying to impose a blanket ban on Muslims entering America. I would be wary of this analysis. If anything is clear, it's that extreme vetting is designed with animals in mind. It's supposed to protect America from rabid jihadists and, really, isn't that something we all want? Liberals may enjoy trotting out smartass facts like 'lawnmowers kill more Americans than Islamic jihadist immigrants each year', but you can't deny that Islam and Islamic terrorism are strongly linked.

Let us imagine for a moment a future for American kids without the threat of radical Islamic terror. Shouldn't these kids be able to go to school secure in the knowledge that all they have in the world to worry about is being caught in the path of a rogue lawnmower? Or becoming a victim of police brutality? Or perhaps being mown down in a mass shooting perpetuated by a classmate? The less gory options are no less frightening for their innocent minds. What about succumbing to a nationwide opioid crisis? Dying an avoidable death due to a lack of affordable healthcare? And even if they escape these horrors, there's always the very real possibility of getting grabbed by the pussy by an aspirational president.

I digress. Whatever your politics, we ought to remember that now is the time for national unity. Don't we all want to make America safe again? I have a modest proposal. (Hear me out,

I'm being practical here. I'm not going to suggest that Muslims eat their own children in order to pre-emptively stop terrorism. That would be too time consuming). Quite simply: I think that we should embrace extreme vetting all the time. We shouldn't just be vetting people at the borders; we should be vetting everyone we meet. We shouldn't just be banning suspicious people from coming in; we should be kicking suspicious people out. I've been proactive and have put together a few pointers that make extreme vetting extremely easy... and incredibly equitable. Commit these guidelines to memory and you'll be able to distinguish an acceptable Arab from a potential terrorist in no time. You'll be part of making America safe again.

Do they have an iPhone or an isisPhone?

Thanks to the FBI's much-publicised attempts to hack their way into the San Bernadino shooters' phones, it's common knowledge that the shooters had iPhones. It might be tempting to thus surmise that everyone with an iPhone is a potential terrorist. However common sense suggests that this is too narrow: iPhone screens, as I know from my own tragic experience, crack easily – making them less than ideal for vigorous terrorist activity. The San Bernadino shooters were outliers and should not be considered representative of terrorists as a whole. Particularly as there is clear data that shows that the Nokia 105 is the preferred phone brand of ISIS fighters. So to be on the safe side, if you spot someone with an iPhone or a Nokia, regard them with immediate suspicion as they're probably a terrorist. Either that or they think it's the 1990s.

Is that body odour or eau de cologne?

Research shows that you can quite literally sniff out a terrorist. According to a terrorist behaviour checklist used by America's Transportation Security Administration for airport screening, 'strong body odour' can be a sign that someone has evil intentions. Other dead giveaways include exaggerated yawning, whistling, verbally expressing contempt for the screening process, and a cold penetrating stare. This checklist, by the way has nothing to do with Trump; it was part of a program (costing almost $1billion) called the Screening of Passengers by Observation Techniques initiated under President Obama. Ah, remember the Obama years? Islamophobia was nonexistent, vetting was extremely benevolent and America welcomed immigrants with open arms, giant hugs and expensive

observation techniques. But enough nostalgia already. While a pungent aroma may signal that there's something a little fishy about someone, don't forget that Middle Eastern men wear a lot of perfume. Even little baby Jesus got a bottle of Frankincense as soon as he was born. So both those guilty of unmasked body odour and overmasked body odour are potential terrorist suspects. Even if they are in fact innocent, it's sensible to keep your distance from these groups of people for your own good.

Are they wearing all-black everything?
I don't want to throw shade here but ISIS really needs to expand its wardrobe. Have you ever seen a jihadist wearing colour? No. They seem to accessorise their monochromatic worldview with a monochromatic wardrobe; everything is just black and white, all the time. Which is a shame because peacock blue looks great on olive skin. This doesn't mean that black clothes always go hand in hand with dark intentions. Many people enjoy wearing black because it's slimming. It's not necessarily Muslimming. Ultimately the key thing to take away from all this is that terrorists generally own some sort of clothing, and some of that clothing is quite likely to be black. The safest holiday hangouts are nudist beaches.

Are they surrounded by kittens and Nutella?
Back in 2015 CNN broke the news that ISIS recruits women with kittens and Nutella. CNN's Carol Costello said: 'ISIS recruiters lure Westerners into their fight because they want people to believe their life on the battlefield isn't so different than yours. They actually eat Nutella, and I guess they have pet kittens.' So if you spot someone surrounded by kittens, languorously spooning Nutella from the jar you should be afraid. Be very afraid.

What's in their pantry?
A predilection for extra virgin olive oil is a sign that someone might be thinking a little too much about the afterlife. You are what you eat. Watch out for foodamentalists.

Are they talking terrorist?
Hearing someone speak Arabic can be alarming for obvious reasons – Arabic being the official language of terrorists and all. So, it's worth becoming familiar with some common Arabic words in order to understand when you should panic and when the conversation is simply Islamic.

Arabic words you should be very alarmed by

Allahou Akbar
I'm going to kill every infidel in this room right now

Inshallah
I'm going to kill every infidel in this room right now.
Hopefully, maybe, we'll see.

Shibshib
While this is just the word for a flipflop/sandal it's
sort of Arab tradition to turn shibshib into dangerous
weapons. If you hear someone say shibshib then duck.
Or get socked by a shoe. Your call.

Falafel
If you get a group of Arabs together in a restaurant
they will inevitably start arguing about who invented
falafel. The Egyptians will say they did; the Iraqis will
say did; and on and on and on. Then the bill will come
and the argument will escalate as they all bicker about
who gets to pay the bill. Things can turn violent quickly.

Arabic words you should not be alarmed by

Habibi
Arabic for friend or significant other (millennials say Habi-bae). Not related in any way to Netanyahu. This is A Good Word.

Hummus
A chickpea-based edible dip that has done a wonderful job of integrating into America. If only more Arabs could be like hummus!

Yallah
It would be logical to think that, because it contains 'Allah', 'yallah' is a dangerous word. On the contrary, however, 'yallah' is very common and largely benign. It means anything from 'OK, we're done with this conversation' to 'hurry up'. Of course, you should always stay vigilant. If someone dressed in black and wielding a Nokia 105 yells 'yallah' at a litter of slow-moving kittens, then—

Are You Talkin' To Me?

Barlon Ansambel – to learn Arabic letters.

50 × 70 cm. Gouaches paint stencilled on recycled paper.

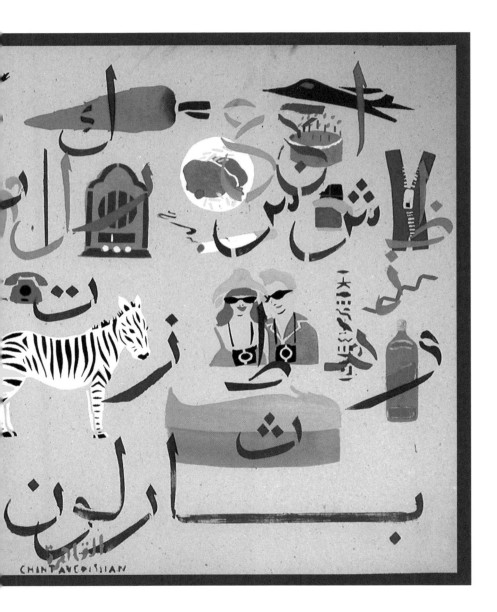

9

Chant Avedissian

*Haya Natakalam – to learn
Latin letters.*

50 × 70 cm. Gouaches paint
stencilled on recycled paper.

THE JOYS OF

APPLYING FOR

A US VISA

KARL SHARRO

FIRST THE IDEA WAS FOR a Muslim travel ban – but that didn't work. Then it became a ban on certain Muslim-majority countries – but that wasn't workable either. *Then* it mutated into a ban on travelling with laptops and iPads. It was as if the Trump administration was thinking: 'We can't stop them coming here, but at least we will deprive them of the pleasure of choosing their own entertainment on the flight.' What next? Travel pillows are denied and strait jackets enforced? America's security, it seems, relies on causing maximum discomfort to travellers from the Middle East.

As anyone who has ever attempted to obtain a US visa will know, the process is so absurd and the odds of success so low that back in the 1980s a man from my hometown in Lebanon became an instant celebrity when he managed to get his hands on one. For the next five years, which is the standard validity of an American visa, the man acquired a mythical status. People would gather around him in the café as he retold the story of how he got the visa. He would pause to take a sip from his Coca Cola, which he never had to pay for, and recount his heroic tale. Years later, people would still refer to him as 'the man with the American visa.'

And yet, here we are. Trump tweeted, 'Our country needs strong borders and extreme vetting, NOW.' Extreme vetting. NOW. I, and millions of others, scratched our collective Middle Eastern head. 'The vetting can get more extreme?!' Naturally, this was ominous news. Millions could lose the ability to travel to the US for work, study, visiting family or, God forbid, tourism.

Allow me to give you a glimpse into the process, which I have pieced together from my own experience and from the man with the American visa's tales. First you must fill out the application forms. Many, many questions designed to weed out the absent-minded

terrorist, the careless smuggler, or the sloppy illegal immigrant who would fail to answer simple questions and give themselves away. *Have you ever been involved in, or do you seek to engage in, money laundering? Do you seek to engage in espionage, sabotage, export control violations, or any other illegal activity while in the United States? Have you ever ordered, incited, committed, assisted, or otherwise participated in genocide?*

When answering these questions, it is important to resist the temptation to express your views about US foreign policy. Like, *What about the shady characters the US deals with who would fail to answer these questions in the negative?* Or: *What about the US's own engagement in espionage, sabotage and clandestine operations in the Middle East?*

In fact, it is best to avoid any kind of elaborate commentary at all, and simply reply 'No', except to question 27 which asks if you have ever eaten falafel. That's a trick question. Composure must be kept at all times.

When you finish filling out the forms, you will need to pay hundreds of dollars in application fees for the honour of being interrogated in person by officials at a US Embassy. Don't balk at the required sum; the US visa is the gold standard of visas and is worth every penny. It's like buying an expensive bottle of wine to impress your friends.

Then you need to assemble a large collection of documents to support your application. These will include details of your financial records, property deeds, pay slips, bank statements, tax receipts, criminal records, letters from your employers, airline tickets, hotel reservations and your grandparents' love letters. Now the latter is not strictly required, but be prepared because you never know which topics will come up in the interview. Oh, and original documents only,

photocopies are not accepted. You would have liked to show them the documents on your laptop or iPad, but you aren't sure whether the electronics ban extends to embassies, too. You will be grateful, after all, to that long lost aunt who kept old laundrette receipts in cardboard boxes under the floorboards 'because they might come in handy one day'. What foresight.

And now for the fun part, the interview. You are given an appointment at seven in the morning, which means you will be seen any time between seven and five in the afternoon. You sit there among the aspiring masses, as the hours pass slowly, afraid to go to the toilet in case your name comes up. A human drama unfolds, as people are called up one by one, leaving with despair, dejection, sorrow or, quite infrequently, elation. Those are the lucky few. The chosen ones. They are patted on the back jealously by the others, as they leave hurriedly, perhaps worrying that the embassy officials might change their minds and revoke their visas instantly. A gold glow and star spangled halo already glitters in their wake as they hurry home to throw parties to celebrate, where friends, neighbours and the son of the man who used to run the bakery where your mum's neighbour bought her bread will visit to congratulate them. Or perhaps you're just slightly hysterical at this stage.

The interview is the high point of the process and requires you to be at your sharpest mentally, nimbly avoiding the verbal traps that the highly-trained embassy official will set up for you. Try to get tips from the people who have already been interviewed, they will give you instant reviews of the different officials. *'Number 5 is tough. He will ask a lot of questions about your finances'. 'Number 3 hasn't approved a single visa today!' 'Number 4 looks like my cousin's dog!'*

And then your number comes up.

You realise that you have been sweating despite the arctic air con because there's a bit of dandruff on the lapel of your starchy suit jacket, which is only wheeled out for funerals and these kinds of special occasions, and you're paranoid that the applications officer might mistake it for cocaine. Although the voice of reason, baffled and oppressed by the current unfolding events, points out that being a cocaine addict is probably preferable to being a terrorist, so maybe you should encourage this impression. Should I frown and risk upsetting Number 2, or smile and make him think I'm hiding something? At this stage your brain is near melting point as it tries to negotiate its way through these impossible paradoxes. Thankfully, the blank-faced official speaks.

– What do you do?

Straight to it, no *hello, how are you doing* or *how can I help you today*. Visa officials dispense with all the courtesies and social conventions of the outside world to establish the power balance instantly. Which feels odd, because this is the most intimate encounter you will have with a stranger, short of a blind date. Over the next twenty minutes or so, you will reveal your most personal details to this person you've never seen before in your life.

– *What do you do?*
– I am an architect.
– *How much do you earn?*

Gee, don't you want to buy me a glass of wine first before asking?

– 1500.
– *That's not much.*

Too bad, I thought we were hitting it off, you and I.

– I should ask for a raise. Any tips?

He examines me briefly with a stone-faced expression, and to my disappointment, doesn't offer any.

– *Are you happy at your work?*
– Yes, I love my work.

At least I don't have to speed date people and then deny them entry into the US for a living.

– *Do you have a car?*
– 1990 VW Golf.
– *Where do you live?*
– Ras Beirut.
– *Do you own the place?*
– No, I rent.

When is it my turn to ask the questions? I have a few good ones.

– *Do you own any property?*
– I inherited an orchard.
– *Where and when were your grandparents born?*
– Sometime, somewhere in the Ottoman Empire.
– *Their birth certificates?*
– I don't have them.
– *Why not?*
– Well, the Ottoman Empire doesn't exist anymore. It's not like I can just pop into its consulate.
– *Are you trying to be funny?*
– No, sir.
– *Why are you planning to visit the United States?*

– To see my friends.

Judgmental look, as if he doesn't believe that I have friends.

– *Why?*
– Why?
– *Yes, why?*

The conversation is clearly taking on a philosophical dimension. Do I need to explain the concept of friendship to him? It is important to avoid being snarky and remain as earnest as possible, for US officials are easily threatened by sarcasm.

– I haven't seen them for a long time and I thought I could visit New York. I hear it's an amazing city.

The official fails to reveal his own thoughts about New York, despite my own eagerness. He changes direction suddenly.

– *Bank statements?*
– It's that one.
– *You only have two hundred dollars in your bank account?*

Alright, no need to criticise my finances. I have to justify my spending habits to you now?

– I was invited to a lot of weddings this summer.

He looks unconvinced.

– Do you have any relatives in the United States?
Well, there is my mother's second cousin but we don't

talk to them. Do they still qualify as relatives? Should I come clean and explain the situation? What if he asks about the reasons for the family feud? I mean not even my grandmother remembers that. But what if I say no and they have supercomputers that know that we are related and he's trying to trick me?

This is the insidious nature of the visa interview process: it forces you to confront aspects of your life you have never thought about. It digs deep into the fibre of your being, asking historical questions, querying family relationships, inquiring about your finances, assessing your character. You need to have prepared answers for all these questions, and yet answer them casually, nonchalantly, off the cuff. You do this all the time. You are a citizen of the world. The best way to succeed is to approach it as if you are preparing to play yourself in a black and white movie about your own life. A somewhat two-dimensional character that would appeal to the US embassy officials. You are not a real person anymore; the usual rules do not apply here. You are a statistic, and your stamp on the world, all you have achieved, has climaxed here, in this 12 by 12 foot cubicle, in a neat pile of a dead great aunt's laundrette receipts.

And so you see, when I first heard that Trump was planning on making it even more difficult for us to travel to the US, I was stunned. What questions would they be asking now? 'Do you know anyone who goes by the name of Muhammad? How about Mohamed?' 'Is this a hipster beard or a religious statement?' 'Does watching *Homeland* make you angry?' 'What was President Trump's golf score this weekend?'

Perhaps it's finally time to start searching for my grandparents' Ottoman birth certificates after all.

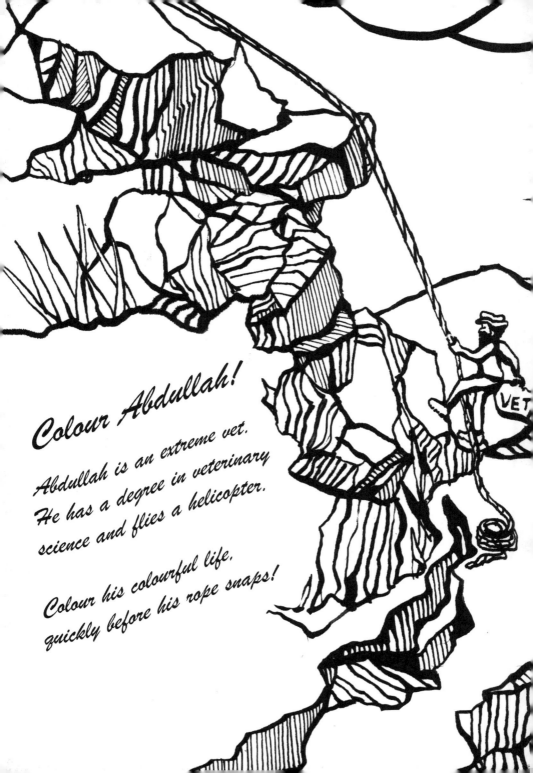

Colour Abdullah!

Abdullah is an extreme vet.
He has a degree in veterinary
science and flies a helicopter.

Colour his colourful life,
quickly before his rope snaps!

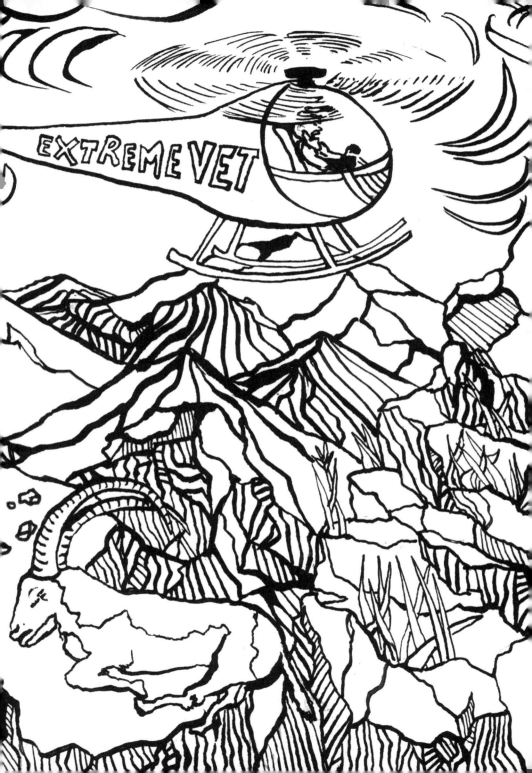

MY OWN PEOPLE

Negin Farsad

MUSLIMS DON'T NECESSARILY HAVE the greatest icons here in the United States. The ones we do have are on the crap spectrum – that's the end of the spectrum that's loaded with bigotry, essentialising, infantilising, theologocentrism and dog poop. Oh yes, I did just casually use the word theologocentrism like it was no big deal. Dropping ten-dollar words has the subtextual weight of saying, 'I read a book once.'

Pretentious ten-dollarness aside, here's the deal with theologocentrism: scholars have had a tendency to explain all observable phenomena in a majority-Muslim country by saying, basically, 'they're like that because Islam.' In some major corners of academia, Islam is a catchall for anything a researcher doesn't understand. Of course it's not limited to academia. The world of infotainment has also grabbed hold of Islam to explain things they can't fully comprehend, by which I mean everything. It's easier to say,

'Post-9/11 terrorism exists because Islam' than it is to say, 'Post-9/11 terrorism exists because the western response to that act of terrorism has been addled by inconsistent policy processes that focused more on war than on nation-building, and those shortcomings have in turn created an environment in which anti-western sentiment might thrive.' See! That shit can't fit on a poster, much less in Don Lemon's mouth.

Because everything spins on Islam's wheels, it's easy to fall into the trap where we take the icons we're given – like gun-toting terrorists or burka-clad ladies – and fight them on their own merits. We end up saying stuff like, 'You can't say that Muslims are terrorists because Islam is peaceful!' I've personally gone on rants trying to explain to people: 'Hold up! Muslims exists on a spectrum; some are very conservative, and others are as secular as your best Christian friend who only goes to church once a year and/or never but still calls themselves Christian. What's the diff, guys!?'

DON'T LIKE ME VERY MUCH

We twist ourselves into knots convincing people that Islam is peaceful and varied before we realise that, wait a second, you can be a Muslim while also recognising that Islam doesn't even explain half of your behaviours! Islam can be peaceful all it wants. It's not the only relevant detail about a group of people. Islam is a hot-button word in the United States, but what if it doesn't explain anything about us? What if it doesn't explain terrorism at all?

It's not for me to explain terrorism – there are plenty of smart people to do that who are not comedians by trade. But I mention it because the need to shoehorn Islam as the major reason for everything in post-9/11 America defines so much of how we see mainstream American Muslims. We've created an arsenal of icons based on this shoehorning, and those icons do not represent me or fit my worldview.

Okay, so if you're like me, you might think there must be cultural touchstones from the mother country to hold on to. Iranians certainly don't define themselves as Islamic terrorists. But there again, for the hyphenated types – your Iranian-Americans, your Moroccan-Irish-Americans – the traditional icons from the mother country don't always work either. For example, Iranians love poetry. That's a nice stereotype and there's truth to it because when in doubt, Iranians will bust out some totally insightful Rumi poem in Farsi. Somehow reciting poetry settles questions, quiets arguments – it's like eating mac 'n' cheese, it makes Iranians feel all warm and mushy inside. But being a poetry nerd doesn't really speak to me. I don't know any of Rumi's poems.

No offense – I'm sure he was a nice guy – but I'm American, so his oeuvre is alien to me. I'm more likely to recite Mos Def.

It's like if you're Russian-American, and maybe you don't want wooden dolls inside of slightly bigger wooden dolls inside of slightly bigger wooden dolls. You take gin instead of vodka, you might prefer BLTs to borsht and you kinda don't 'get' Yakov Smirnoff. But at the same time you might not understand why Americans go Dutch on bills, why they're so friendly to strangers, or why they take improv classes. Because you're not fully American either, you're this Third Thing, you're a Russian-American and you have to forge this Third Thing identity in the United States. And it's not easy.

Like the hypothetical Russian-American, I'm a Third Thing – Islam doesn't explain me, Iranian poetry doesn't explain me, and apple pie doesn't explain me. And yet I understand all of those things. Being a Third Thing is a designation for people who straddle worlds, who may have a foot in every door yet their butt is hovering between door frames and they may even have more than two feet, and either way they're definitely going to pull a groin muscle.

How do you know you're a Third Thing? For me, after the world got stuffed with Muslim iconography I didn't recognise but was lumped into, that was when I knew. You know because you've been squeezed into a category that may technically be true but still doesn't fit right. You squirm in it. It's like having a rock in your shoe or wearing underwear that rides up your

junk. Sure, they're technically underpants, but they don't fit right. Sure, I'm Muslim, but the way some people say it rides up my junk.

You also know you're a Third Thing when you hang out with friends and you will totally dump on your own people but get very mad when anyone else tries to join in on the dumping. I can say all I want about Iran, but you!? You better be careful, because I'm not gonna let no one talk shit about Iran! But, you were just saying how – nuh-uh, zip it! You're a Third Thing when you complain about the identity and you defend the identity in equal parts.

If you're not a Third Thing, let me try to explain the feeling. Have you ever been at a summer camp that was overly athletic? (... she says, having been at a summer camp that was overly athletic.) You're supposed to be excited, you're supposed to have fun, your parents drop you off at this day camp every morning and you are filled with ... dread. And then one day you find out that some of the kids are doing crafts off the field in a room, with window screens to keep out the bugs, and you ask if you can join them and be a part of that summer camp? There's papier-mâché and paints and puppets, and it is heavenly. That's when you know, you are the kind of person who likes 'summer camp' writ large, but you're not the type of person who likes the sports part. Some might call you a nerd. If sports and arts and summer camp were nations, immigration stories and ethnicities, you would be a Third Thing. Except that Third Things are kind of

third-y all their lives, and summer camp is only six weeks long.

Even though my parents are full-on Iranians, I never learned the intricate customs – there's a far-reaching set of rules and a whole language of etiquette. It's so complicated! You could offer to buy someone a coffee and it could be interpreted as an insult depending on the other person's relative age, income, citizenship status, gender, level of indigestion ... I mean, it's nuts. My parents gave me some basic Iranian rules, but by no means all of them (plus I think they find it hilarious when they see me struggle). So, when I meet Iranians, I can speak to them in Farsi, and I can say nonformal American-style greetings, but I'm always inadvertently breaking rules that I didn't even know existed!

All of this happens because I'm that weird Third Thing and I'm trying to forge my own way, but it's not easy. And when you're a Third Thing, you're addressing a heretofore nonex-istent Third Thing Audience or Third Thing–Sympathising Audience. You're now the de facto voice of your people's Third Thing sub-group, and the people in the First and Second Things aren't necessarily going to like it.

I feel like I've been trying to build a Third Thing–Sympathising Audience since I was a kid. In the professional world of comedy, trying to forge this Third Thing identity has been a task, lemme tell ya! I once made a film for which my fellow comedian Dean Obeidallah and I rounded up a bunch of Muslim-American comedians – in a non violent way – and we toured the country.

We went to places like Tennessee, Alabama, Mississippi, Georgia, Arizona, you know, places where they naturally love the Muzzies. We called the tour (and subsequent film) The Muslims Are Coming! which to some meant 'preventative warning lecture on the coming Muslim apocalypse' and to others meant 'live Muslim fetish adult pornography'. To most it meant 'stand-up comedy show featuring Muslims'.

Now I'm not gonna lie: when we first set out to do these shows, there was a lot of concern. Friends in New York thought that people in the deep South were going to react badly. They thought that people would say mean things and maybe even ... do something physically violent. I definitely was not as concerned about the violence because I thought, come on, I look like a cartoon character, with the voice of Butters from South Park. How could anyone attack me?

And yet, we did plenty to elicit public attention. We would set up an 'Ask a Muslim' booth in the middle of a town centre so people could ask us questions. We invited people to come 'Bowl with a Muslim' – an event that taught us that Muslims bowl very badly. (This explains why Barack Obama bowls so badly.) We handed out flyers at farmers' markets and gun shows and we were generally visible.

It was the visibility that had my friends and family concerned. Let's be honest – the South gets a pretty bad rap. They thought those Southerners were gonna brutalise me. That they were gonna unfurl large-scale

Confederate flags and protest my shows. That they were going to show up chewing tobacco and demanding the immediate deportation of all Muslim comedians.

Basically, the South has a PR problem not unlike that of Muslims. Because the Southerners I met (not to mention the large number of Mormons I met in Utah and, Idaho) were far from that. They were open, welcoming. They had honest questions about us – questions like why don't we denounce terrorism, or would goldfish constitute halal food. I didn't find them particularly racist, I didn't think they were trying to run me out of town, and I generally had a great time. I did see too much gun appreciation in the South, but nobody's perfect.

Coyotes do not fear humans and will readily attack lone hikers.

The diner waitress wore the pink uniform from 1967 until 2017.

A sock on the door means a frat brother has a girl in there with him.

The security guard didn't believe I was speaking at the conference.

The pap-pap of a cowboy pistol sounds like bailiffs knocking for rent.

My perpetrator and his lawyer went to the same school and university.

At Halloween masked children go from house to house, begging.

If strangers do not give you treats, threaten them with harm – a 'trick.'

In major firms female executives start getting Botox at twenty-three.

Do not jog alone or after dark and always face oncoming traffic.

They prayed together in silence in the bare white church.

The panic room is equipped with a direct line to the police.

The theatre staff searched our bags but let twenty college kids through.

Armed men appeared at the edge of the planters' field/village/campus/square.

We have the emails you sent to my client which prove he did not rape you.

I stood on the balcony in my robe, smoking and looking out on the valley.

There was a snap and a cry in the distance and smoke rose up like dusk.

When the police did nothing my brothers took him to a field and beat him.

Forty-five minutes of hot yoga are followed by an oil massage.

Why isn't your husband travelling with you Ma'am?

She is a fantasist whose allegations are simply not true.

He had a white Cadillac that he buffed lovingly every weekend.

If you feel like dancing during the chorus, go ahead and dance.

They took blood and did a saliva swab in the waiting room.

Do not bribe, use sarcasm, joke or attempt small talk with officials.

To climb razor wire, throw a thick blanket or tarpaulin over it.

The brotherhood was led by an old boy they call Beauregard.

The snow that year reached as high as the kids' bedroom window.

The officers traded emails and photographs mocking the victim.

After four years the janitor's uniform is upgraded from brown to green.

In the park I was followed by a man in a camouflage print jacket.

The innocent stay awake, scared of being beaten by day or raped at night.

I did a holiday where you hunt, shoot, skin, cook and eat a deer.

After prom they dumped her on the porch of her parents' house.

We always go upstate in autumn to watch the leaves change colour.

He has a main partner, mistresses, two side-pieces and whatever groupies.

He tore up the contract in her face and sent her back out again.

My cousin killed himself at twenty with a gun he obtained legally.

We bond the extensions to your natural hair using waterproof glue.

Under starvation conditions, the eyesight rapidly deteriorates.

The company deny a link between ADHD medicine and violent behaviour.

She sidestepped the rug because she thought it was a prayer mat.

One innovation is the use of plastic ties instead of handcuffs.

He invited me to his hotel suite to talk about upcoming projects.

When I asked why she'd thought I was Muslim she said she was tired.

The officer's bodycam failed to record the exact moment of death.

She wears a dress by Ralph Lauren and a Bulgari necklace.

Every time I see him pretending to be a 'nice guy' I die inside.

I told the Prime Minister and I'm telling you, we don't want these people.

Anyone can be anything in this country.

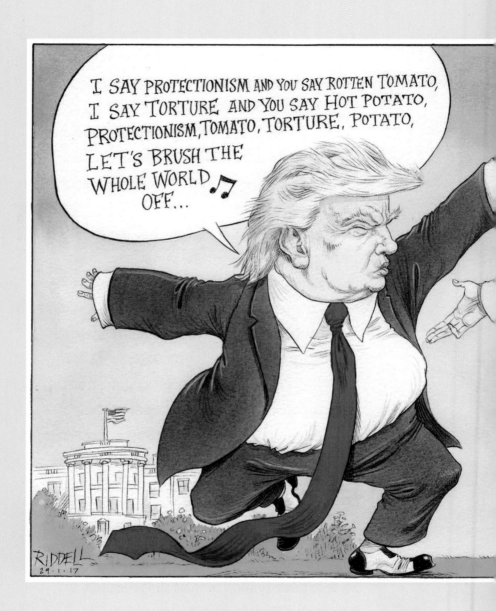

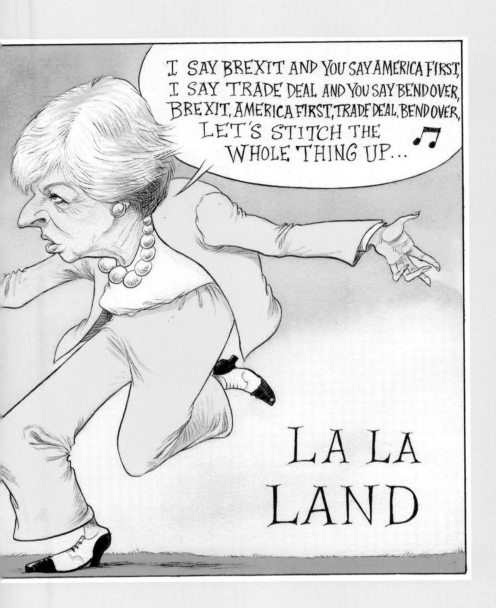

CHRIS RIDDELL

TRUMP

Hazem Saghieh

One doesn't need much in the way of psychoanalysis to observe that Donald Trump has developed in a very *uneven* way. His age and the size of his body have increased, as they do for the rest of humankind, but his mind, in contrast, has not.

This problem is not unique to Donald Trump. Yet what is particular to his case, and what makes this dilemma more complicated, is that the man has made it. He became a billionaire, then a television star and, finally, the president of the richest and most powerful nation on earth.

This is what's aroused such a great deal of confusion. There are plenty of simpletons gazing into the lives of the rich and famous through the television, including those who see Trump as rather clever. As Abu Mustafa, a friend of mine from Beirut who works as a bus driver, told me, 'He must be a genius. Anyone that successful is definitely a genius.' When I tried to tell Abu Mustafa otherwise, he shook his head, and I think he started to doubt whether I myself was at all clever.

Just a few moments passed before Abu Mustafa seemed to doubt what he, not I, had said. 'Why does Trump's hair look like that?' He asked me. And when I told him that's something personal, none of our business, he objected. 'Trump's hair is a sign that there's something strange about him,' Abu Mustafa said. 'The public has a right to intervene in the president of the United States' affairs, because everything concerning the president of the United States is a public affair. When people said Barack Obama and John F. Kennedy were handsome, no one told them that's something personal. Why do people use that excuse only when someone brings up something hideous?'

As I began to think about what Abu Mustafa said, he went on. 'You know who Trump reminds me of? Muammar Gaddafi. Gaddafi died before his time. He was a strange one, way before Trump. If Gaddafi were still alive today, I think he and Trump would be great friends.'

Gaddafi was also incredibly uneven, and plenty of people considered him

AND

quite successful and clever, given that he remained in power for more than forty years. Of course, much has been written about Gaddafi's success and cleverness. We know today that he got what he wanted because he crushed his opposition, pushed them into exile, and had them assassinated. Abu Selim Prison was destroyed with the prisoners still inside.

Abu Mustafa made up his mind on the matter the next day. He came up to me, and said apologetically, 'I don't think the US president is clever. He only ever says two things: 'pay up' and 'get rid of'. To the Mexicans, pay for the wall. To the Europeans, pay for your own defense. To the Arabs, pay for establishing a 'safe haven' in Syria. And on the other hand: get rid of NATO. Get rid of trade deals. Get rid of Obama and Kerry... this man only knows two phrases in the whole English language.'

This discovery of Abu Mustafa's landed him in another predicament: 'Is that what it takes to be a success nowadays: not knowing more than two phrases, and having a huge gap between your physical and mental development?' My friend paused, before his thoughts turned back to the former ruler of Libya. 'It's true that Gaddafi rose to success first, and ruled like an emperor for decades. But he ended in a pretty bad way. Don't you think?'

Translated from Arabic by Elisabeth Jaquette

GADDAFI

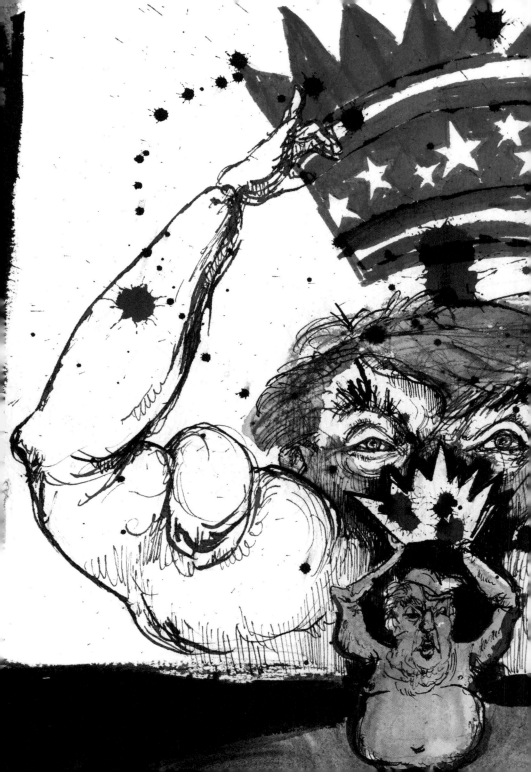

TRUMPINATION

The Trump Inauguration

MOLLY CRABAPPLE

UK Researchers:

ISLAM IS NOT SPIRITUAL, BUT IT IS A USEFUL IDENTITY

Omar Hamdi

RESEARCHERS AT SSIC (School for the Study of Inferior Cultures) at London University have concluded, after an extensive one-week study, that Islam is 'just a useful identity' and 'not a spiritual tradition.'

Mariam Amélie, who led the study, said, 'There are some people out there who think Islam is a spiritual tradition, concerned with matters such as combating the ego, selflessness and purification of the heart. They're wrong. The results from our study undisputedly show that Islam is in actual fact, technically, an identity – like being black, or a goth (they're black too, but the

first time I was talking about skin, not clothes).'

Ms Amélie's findings were welcomed by Dr Tariq Shaban of the campaign group Muslims with Attitude (MWA): 'It's very seventh century to think of Islam as a spiritual tradition – that's the kind of stuff Prophet Muhammad actually taught. I actually prefer to think of Islam as an identity. I'm a proud British Muslim – as of last week (the British bit, I mean). There's nowhere else in the world where I would be able to get so many angry brown people together to attend demonstrations on such a regular basis as in Britain. Most of those attending our demonstrations don't actually pray. The most important command in Islam is to be angry. And it is such a universal way of life – you can be angry about anything you like – Israel,

Syria, silly cartoons... This is what makes it superior to western culture, where people are only allowed to be angry about unimportant things, like Oscar winners or dead gorillas.'

The long-awaited findings have been welcomed by politicians from across the political spectrum. Lianne Abbott MP, head of the All Party Parliamentary Group on Box-Ticking, said, 'I have a lot of Muslim constituents, so the more we can make them into a homogenous group without any individual opinions, the easier it is for me to stay in my seat in parliament – and I'm not planning on getting up any time soon. I welcome Ms Amélie's findings. She might even be made a Baroness on account of her labours (although she categorically hasn't been promised anything by our party leader).'

On the other side of the political divide, Lord Crinklebottom, founder of the BEAS (British Empire Appreciation Society), said, 'It makes much more sense to me that those bloody brown people have an identity – like a tribe – rather than a religion with actual spirituality, literature and music. Otherwise, they'd be just like Christians, and we all know that's simply not true is it?'

Ms Amélie has been forced to defend claims that her research lacks rigour. 'People think I don't know anything about Islam because I'm not a Muslim. But that's a spurious allegation because my ex is half Moroccan, and I love shisha, so I feel very close to the community. Plus, my father owns a house in Spain and that was

'There are some people out there who think Islam is a spiritual tradition, concerned with matters such as combating the ego, selflessness, and purification of the heart. They're wrong.'

ruled by the Moorish caliphate until 1492, so I understand ISIS better than anyone. Better than they understand themselves, in fact.'

'I just want people to realise how great Islam is – as an identity of course, not as an actual spiritual tradition. Last year I told people I actually was Muslim, and it was amazing for my career. I was on TV, like, every Sunday morning, and all I had to do was put one of mum's Gucci pashminas on my head, and act angry. I've heard that if I go 'full-time Muslim' I could get tenure at Cambridge. It worked for Dr Shaban – he's got his own section at Waterstones shops up and down the country. Right now, I'm working on a hijabi dating show for a well-known youth channel – it's so important to raise awareness that girls in headscarves can be quite shaggable, especially considering the toxic rhetoric around Brexit. I would hope that one day members of the UK Separation Party will swipe right on a hijabi – far right. We're talking to Nike about a sponsorship deal.'

A
SIDON–GATESHEAD
UPBRINGING
(IN ESSEX)

ESTHER
MANITO

M Y FATHER IS FROM SIDON in Lebanon; my mother from a working class Anglo-Irish family in Gateshead. I was brought up far away from either city, in a remote English town in Essex. If that combination isn't complex enough, as an extra bonus gift, god also blessed me with enough body hair to stuff a mattress. I was the very hairy nine-year-old with the kind of mono-brow that would make even the Gallagher brothers jealous (it practically met my hairline, leaving me without a forehead). In a school filled with blonde, blue-eyed English roses, I was very self-conscious.

I used to get a fair whack of racism at school. The retro racist classics were regularly slung my way, including 'terrorist', 'rag head', 'dirty Arab' and 'camel' (that last one was a particularly threatening insult, which hit me hard…). I got so fed up with losing my rag (yes, pun intended) that I realised that I had to develop a strategy of self-defence. Comedy became my shield, and so all the insults became mere fertiliser to help nourish and develop my sense of humour. I used to enjoy playing with peoples' general lack of knowledge about the Middle East and yes, looking back on it now, I did at times exploit other peoples' naivety for my own amusement. At primary school I performed a Lebanese dance in assembly. My parents and older sister sat and looked on in confusion as, having no knowledge of this dance whatsoever, I writhed around on stage with a keffiyeh (a checked Palestinian

scarf) in one hand and my mum's pashmina from the market in the other, making it up as I went along. At secondary school, for a presentation in a Religious Studies class, my sister and I invented a faux Lebanese festival, which we called *The Festival of Fruit*. We held up a mat with a picture of the Taj Mahal on it (the same mat my mum would put on the floor when I was painting to stop me spilling any paint on the carpet). My teacher phoned my dad after it eventually dawned on him that perhaps this was not entirely accurate. My dad was livid. 'You are misrepresenting my background! You made us look like idiots! Who prays to the festival of fruits?' I sassily replied, 'It's *fruit*.' (Heavy emphasis on the 't'). I got a clip around the ear.

The truth is that I had no idea what my background was. I couldn't be 100 per cent English with an Arab father. But my English accent and the fact I didn't speak Arabic meant I never felt Arab enough. And my mother wouldn't let us forget her working class background either; some of my fondest childhood memories were at the working men's clubs in Newcastle. So my sisters and I were middle class Anglo-Arabs with ties to Gateshead, Ireland and Lebanon.

Their differences aside, my parents certainly had their sense of humour in common. On reflection, the rows they had would have made comedy gold. My mum would yell at my dad, 'Oh the irony. "Trousers" and "shoes" lose their plural and become "shoe" and "trouser", yet my sister, whose name is Jean, has been referred to as "Jeans" our entire marriage!'

My husband is English. We have been married for eight years and have two children, yet he still signs my birthday cards, 'Kind regards, Neil.' He had little to no knowledge of the Middle East before we met. A favourite pastime of mine was convincing him to believe in various fictional Arab traditions. When we first started dating, my mum and I told him that according to Lebanese custom, the first time a boyfriend stays at his girlfriend's parents' house, he should sleep in the same bed as her father. My future husband's face dropped as we explained that he would be sharing

a bed with my father, Ziad. He turned visibly pale as my dad burst into the living room in just his boxer shorts yelling, 'This bastard, Tony Blair!', brandishing a copy of *The Guardian* in his hand.

That's another thing about dad – he is always yelling. Arabs yell. Fact. If they are happy, they yell, if they are sad, they yell, if they are indifferent... Well, that's ridiculous. Arabs are never indifferent about anything. My dad has phone conversations about the weather with his brother in Lebanon, but he yells so loudly that flocks of birds flee the trees outside. I love watching an Arab speak on the phone. Every time they mention someone who is sitting in the room with them they use their eyebrows to point to them '*Yani* Esther (eyebrow pointing to me) is working as a clown now.'

My dad is very involved with my kids. At one playgroup, my dad and I were sitting, watching while a boy pushed his mum to the edge. All eyes were glued to her, judging her for her son's behaviour. I wanted to hug her and tell her that she was doing a great job. Then, my son, who was only one at the time, started to whimper because he wanted another boy's toy. My dad turned and in no uncertain terms stated, 'Don't even think about it. I don't negotiate with terrorists.' My dad started chuckling away while my son beamed up at the familiar sight of his grandad laughing at his own jokes.

Hassan Hajjaj —
' Kesh Angels

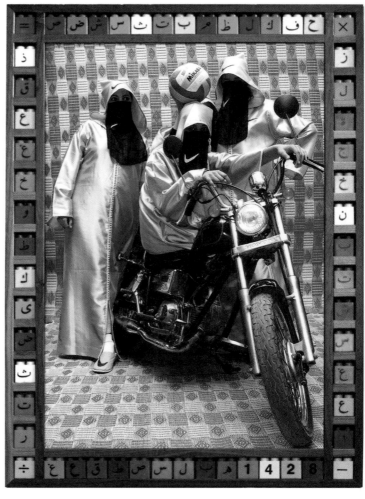

Nikee Rider
Photography by Hassan Hajjaj 2007/1428, Ed. of 10.
Digital c-type on dibond, wood frame with Arabic lego.

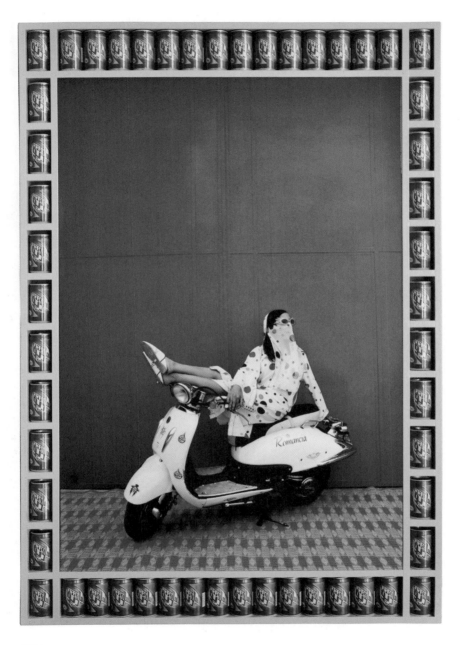

Miriam
Photography by Hassan Hajjaj 2010/1431, Ed. of 7.
Metallic lambda on dibond, wood frame sprayed yellow gloss with soda cans

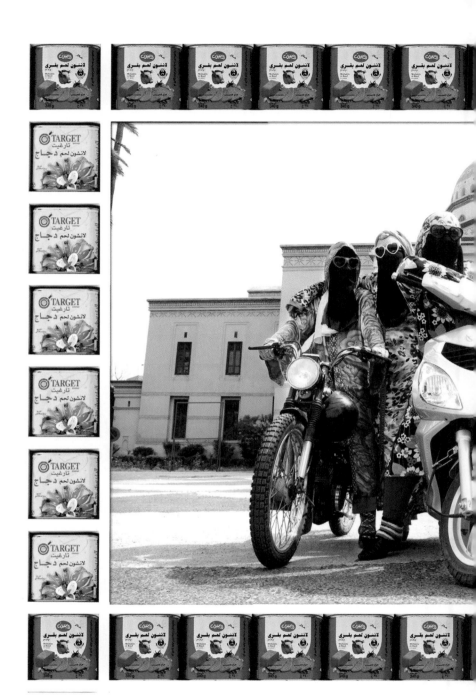

Kesh Angels
Photography by Hassan Hajjaj. 2010/1431, Ed. of 7. Metallic lambda on dibond, wood frame sprayed white gloss with mixed Arabic cans

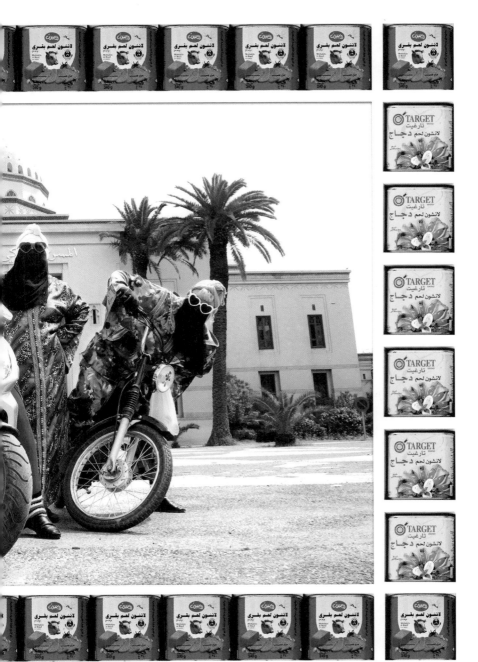

Do I Understand That You Are a Homosexual, Sir?

Saleem Haddad

*Y*ou might want to wear *a floral sweatshirt. It will make you appear more optimistic. The one you have on from H&M is certainly a statement piece. Nothing says 'FUN' like a beige sweatshirt with enormous lavender and pink flower prints. You might be thinking that such high street attire might appear basic, perhaps a bit 'terrorist-y' even. But don't pontificate about fashion choices. It's too late for that now. You think a floral sweatshirt is going to change the fact that your middle name is Muhammad? We're too far gone for that. No, the sweatshirt is intended to make you seem easy, breezy, cover girl, and that's the vibe you need to project right now.*

If you want to get on this flight you'll have to follow my instructions carefully. First, stand up when they announce that they've begun to board passengers. Be cool. Maybe smooth out that sweatshirt. Pick up your bag. Glance at the ticket. But only a casual glance. The gate is there… and do you see him? That man in the suit, clean-shaven, buzzed haircut. Yes, the one with his hands in his pockets, standing just behind the stewardess who is checking boarding passes with an ennui so devastating it's poetic. That's him.

Don't make eye contact.

Approach the stewardess. Act natural. Smile… wait, not that widely.

You're showing too much teeth, you look like a lunatic. There you go. Now hand the woman your boarding pass. She will scan your ticket with her machine. The machine will beep. That's it. It beeped. Stay calm. She's going to check your seat number against the list on her notepad, and any minute now…

'Sir, I'm going to have to ask you to step aside and speak to this gentleman behind me.'

What, did you think you were getting upgraded? Oh habibi, please. Now smile and say…

'That's absolutely fine.'

There you go. And there he is. The man. Standing between you and the air bridge leading to the plane.

'Good evening, sir. I work for the US Department of Homeland Security. If you don't mind, I'd like to ask you a few questions before you board the flight.'

If you took my advice you should be about two Valiums deep right about now. Don't act overly friendly, but don't be too standoffish either. That's what the Valium is for.

'Of course.'

'Have we stopped you before?'

Of course they've stopped you. Every time you fly to the US they've stopped you. But don't get smart…

'Sometimes…'

'We do random checks.'

Yes, I realise this is patronising…

'I understand. You guys are mostly nice.'

'We try to be, sir. What is the purpose of your trip to the US?'

Don't overthink this. Just say something like…

'Vacation.'

Flawless.

'What do you intend to do while you're in the country?'

Your itinerary reveals everything about your character, so think this through carefully. Disneyland is good, but also difficult to pull off unless you've got kids. Americans always appreciate shopping, especially if you can name a few stores. Museums are also good. Everyone knows

that terrorists don't like culture. Less appreciated are any references to buildings or landmarks: the Statue of Liberty, the Empire State Building, the Golden Gate Bridge. These kinds of places scream terrorist.

'I'll be in New York for the week. I'm probably going to do some shopping… maybe see a show. Then I'll spend about a day or so in my Airbnb doing some productive crying. I also want to check out this ramen place in Brooklyn I saw on Instagram.'

Nice touch with the ramen.

'Do you know anyone in New York?'

Look, I don't want no 'Ahmad' or 'Ali' or 'Zubaida'. Give me a Mary! Give me a Jonathan! Give me an Angela! Give me an Andrew! Give me blonde hair, blue eyes, vanilla skin! Give me someone who knows how to ski! Give me—

'No. I'll be alone.'

Well that explains the crying.

'And when were you last in the United States?'

'About a year ago.'

'Can you tell me which countries you've visited in the last twelve months?'

Here we go. Now start with the good countries…

'I travel a lot for work.'

'Try and remember what you can, sir.'

I think Switzerland is a good one to start with. But wait isn't Europe overrun with Muslims? Okay, somewhere else. How about Malaysia? No, that's an Islamic country. Taiwan? Yes, Taiwan. No Muslims there. Go with Taiwan!

'Lebanon…'

'Lebanon?'

Really? Lebanon. That's the country you chose to start with?

'Yes. Lebanon.'

'What was the purpose of your travel to Lebanon?'

'Seeing friends.'

'And, sir, while you were in Lebanon, did you travel to any Hezbollah strongholds?'

Well you did sleep with that guy from Dahiyeh that you found on

Grindr. He wasn't a Hezbollah supporter but he certainly had quite a 'strong hold' on you, pardon the pun. The first question he asked was which sect you were from and the second was whether you were a top or a bottom... Got to love the Lebanese.

'No.'

'Where else have you travelled?'

Give yourself a break, hayati...

'Paris. Milan. Ibiza. Dubai...'

Good boy.

'Hong Kong...'

'Is that it?'

'Ummm...'

Now it just looks like you're hiding something...

'Jordan, Turkey, Egypt...'

There you go. Just let it all out.

'Libya.'

'Libya?'

LIBYA?!

'Yes. Libya.'

'And what was the purpose of your trip to Libya?'

Make something up. Anything.

'I work between Libya and London...'

'Why is that?'

No, please... Don't say it.

'I work for my father's company. My father is Libyan.'

Oh honey. Tell him you've always wanted to go into fashion. Show him your Internet history. Do something, anything, to wash the Libya off you.

'Sir, do you have any other passports other than your British passport?'

Zip it.

'Not on me.'

'But do you have any?'

Not a word. Nothing.

'I have a Libyan passport.'

'May I see it?'

Please tell me you didn't bring it with you. Have I taught you nothing?

'I didn't bring it with me.'

Allahu Akbar, you're finally listening to me!

'Do you know, or have met with, any Islamist individuals or groups in your line of work in Libya?'

No. Nothing. Nada.

'No.'

'And personal life?'

Quick and easy…

'None.'

'Are you sure?'

'What do you mean exactly by "know"?'

You're thinking of that guy you had under the bridge, aren't you? The Misratan militia dude. Well, that's what you assumed he was, with his gun and his beard and his swagger. Kind of 'Islamic-y', I suppose, even if he did let you run your fingers through his beard.

'What do you mean by "what do you mean"?'

Wait, what are you doing? You didn't even have sex with him! That doesn't count as 'know'. In gay terms that barely counts as 'met'!

'I met some guy who was part of a Misratan militia. I guess it was an Islamic militia but I don't know the name of it.'

I give up.

'Just met, sir?'

You nearly had him, too. But then he asked if anyone had penetrated you before. You told the truth and he left, saying he only sleeps with virgins. Learned your lesson, didn't you? There are about fifty men walking around Libya right now thinking they've taken your virginity…

'Well… a bit more I suppose.'

… You're such a good actor. Trying to act all in pain. They hold you tenderly and say 'It's okay habibi, just relax and push, like you're making kaka…'

'What do you mean by "a bit more"?'

Don't say it.

'I gave him a blowjob.'

Well, there we go. It's all out now, isn't it?

'Excuse me?'

'I performed oral sex on him.'

He treated you with a roughness that was at moments tender, with a touch of pity that you had failed to reach his levels of manliness... Not so much like a man treats a woman, rather like a father would treat his stunted child...

'Do I understand that you are a homosexual, sir?'

Someone give this genius a Nobel Prize.

'Yes, I am.'

'And can someone be both a Libyan and a homosexual?'

'I think so, yes.'

'Sir, as you know with the new regulations, I have to ask you this...'

Here's your chance. Flap your wrists and tell him you've been exiled. Regale him with tales of 'suffering'. Don't you want to try that ramen place?

'...do you feel yourself to be more Libyan, or more homosexual?'

Okay, let's think about this carefully. I suppose your penis feels more homosexual. Doesn't your penis have a Cindy Crawford mole? That's such a homosexual thing for a penis to have... but then do you remember when you picked up that twink in that club in Soho, and you didn't know he was Israeli until you were both naked and staring at each other's circumcised penises, and then you finally noticed the Star of David tattoo on his wrist?

'Umm, do you want me to give percentages?'

'Well, I suppose that would help, sir.'

...Sure, that night you were both drunk enough and laughed it off. His lips were gorgeous and you spent the night making out. But, the next morning before you left, you wrote your name down so he could add you on Facebook. When he did, you went through his photos and there was a photo album dedicated to his military service, and you secretly wished you had fucked him so that perhaps you could have done your bit to liberate Palestine (is this your internalised misogyny

talking?). Your penis felt very Libyan then, didn't it?

'I'll say 90 per cent homosexual and 10 per cent Libyan.'

'And, sir, like, in your heart… does the 10 per cent that is Libyan have positive feelings towards America?'

The flight is closing. Tell him about your Cindy Crawford mole!

'To be honest, America makes me feel anxious.'

What is it with you Arabs always making life difficult for yourselves?

'Anxiety over what? Like because of our freedoms?'

'No, because of your freeways. They are enormous and never-ending.'

'They are indeed, sir. Much like our freedoms. Anyway, thank you for your cooperation. Enjoy your trip.'

'Thank you.'

'Say… it must be tough to be a homosexual over there, no? So much hate and fear…'

I told you the floral sweatshirt would work.

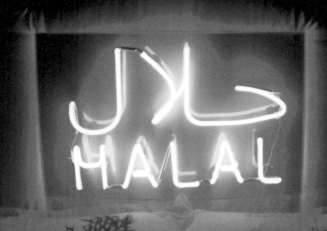

Rana Salam

Sexy Souk

How ISLAM
taught me to be

A
DRAG
QUEEN

❧

Amrou Al-Kadhi

I GREW UP IN THE MIDDLE EAST and was raised Muslim. I now live in London and am a professional drag performer. The obvious transition.

If I were to write a memoir it'd be entitled *Glamrou: From Hijabs to Hollywood.* Following the book's sell-out success, I'd release the sequel, *Glamrou: From Burkas to Bikinis.* And the climactic finale to my life-story trilogy would be *Glamrou: From Quran to Queen.* As someone having journeyed through royalty (from Arabian palaces to Queer martyrdom), the final biopic would of course be written posthumously.

As each title might suggest, I've endured a seismic cultural shift, running from an Islamic Arab household to the glittery arms of the queer London drag scene. The switch could be interpreted as a radical one; like a fervent Marxist becoming a Wall Street tycoon. But it would be misleading to think of my two worlds as opposed. For my drag career is intrinsically linked to what I learnt from my Muslim upbringing. Without Ru Paul to coach me through gender non-conformism, my Iraqi family were – unbeknown to them – the way I learned the queer art of drag.

MY QUEEN MOTHER, AND HER PENCHANT FOR DIAMONDS

The modes of masculinity in Arab households aren't exactly inspiring. As a child, I was decidedly out of place at the monthly Muslim weddings, where I secretly prayed I'd end up marrying Robin Hood (who I only knew as a cartoon fox). The men around me were devastatingly dull. Cigars always in hand and mafia-gangster bravados assumed, 'business' conversations hovered between the strict parameters of gambling, football and cars.

While my (heterosexual) twin brother was seduced by the fumes of the legs-spread male gamblers, I looked elsewhere for aspiration. I didn't have Cher and Madonna to guide me through queer confusion – I genuinely didn't know they existed – and so without them, my Iraqi-Egyptian mother became an unlikely queer guru.

My mother would meticulously construct an image of glamour even if she was only going to meet a friend for coffee, or to drop us off at school. For the most parochial of activities she'd be drenched in (fake-)emerald jewels, towering designer heels and pseudo-couture dresses. With lips painted to achieve a reptilian gloss, she agonised over where to draw her beauty spot for the day.

It was through my mother that I developed a queer love affair with femininity. To be honest, I feel like I *am* her each time I get ready for a show. My mother for her part was not best pleased about becoming my go-to-guide. She made an effort to stifle all gay 'tendencies' during my adolescence. This included throwing out colourful bits of clothing, forcing me to learn the 'manly' way of walking (I had been imitating her treating street pavements like catwalks) and on one memorable occasion, screaming with tears and grounding me when a gay porn DVD was discovered (the cover of which boasted two men rimming).

In hindsight, I realise that my mother's queen-like social costume was the very outcome of Middle-Eastern heteronormativity – she was performing the male expectation of ideal femininity.

I'm glad, I guess, that in my own way I've rescued the memory of my mother, so that she lives in my head as a queen running free. And now that we've parted ways I go to Harrods when I need inspiration and gawp longingly at the bejewelled Arabian goddesses whilst they nibble on pink Ladurée macaroons.

THIS GIRL IS ON FIRE: VISIONS OF HELL

I spent my childhood between Bahrain and Dubai. It was mostly happy and carefree, with the exception of one hour every day when I was summoned to a compulsory Islam class at school. We were taught many interesting things, including that every sinful thought culminates in ten negative points collected on your left shoulder, while every good deed counts for one measly point that collects on your right. The outcome is simple. If you stack up more

on your left, you spend an eternity in hell. As I was furtively plotting anal sex in my head for the duration of most of these classes, by adolescence my left shoulder had an approximate million-point advantage over my right.

When you're taught about hell as a Muslim kid it becomes a highly sensory place. Every day we were guided through the ins and outs of a lifetime inferno. Through visual descriptions, we were taught to picture ourselves hanging from ropes above pits of fire. Scary, huh? (Erotic, too.) The intensely visual nature of placing yourself in hell is absurdly theatrical. The heat emanating from the waves of fire as God weighed your sins on a pair of scales felt more like performing in a camp Italian opera than punishment. Although intended to scare me into submission, the hysteric theatrics of Satan's crib thrust me instead into an obsession with the visual. Heaven felt cold and frosty to me: zombified, even. Hell, however, was a place on fire, with beasts, dungeons, saunas of sweaty men and a non-stop thumping disco. Drag for me is rooted in my love of visual transgressions – subverting images of masculinity and femininity through costume and make-up. And each time I dress up as an Arabian warrior princess, I channel the transgressive and fiery feeling of hellish flames.

The intended punishment of being made to visualise an eternity of fire has led to a career of quite literally being a girl *on* fire. Every time I go on stage in drag, it's as if the internal red poker of self-flagellation is set free, hopefully giving audiences one hell of a time in the process.

* * *

When people are quick to position Muslims and Arabs as 'barbaric', I like to tell them my story. For my Islamic upbringing formed the genesis of my career as a queer warrior unicorn. Unwittingly, I've always had a home in Islam, even if at times it has felt inhospitable.

And so to all potential biographers reading this essay, all fighting for the option rights to *Glamrou: From Quran to Queen*, please don't overlook Islam's complexities. For there is queer magic inside it – if you know what you're looking for.

CHAZA CHARAFEDDINE
DIVINE COMEDY

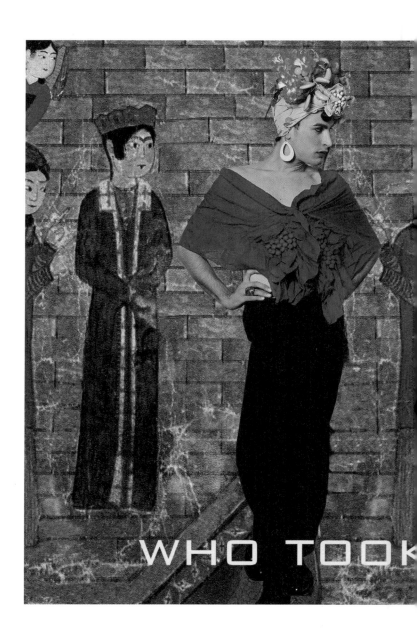

WHO TOOK

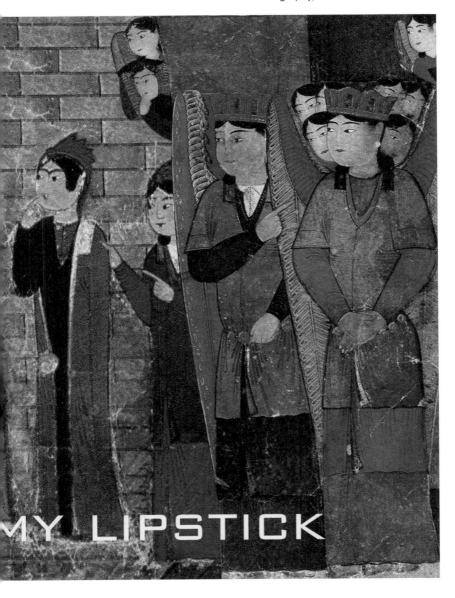

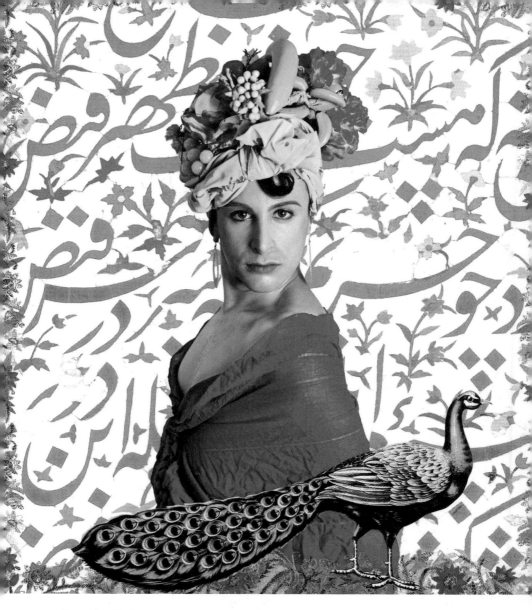

Dame Aux Fruits
Photography, 100 × 99 cm

Sultane
Photography, 100 × 75.28 cm

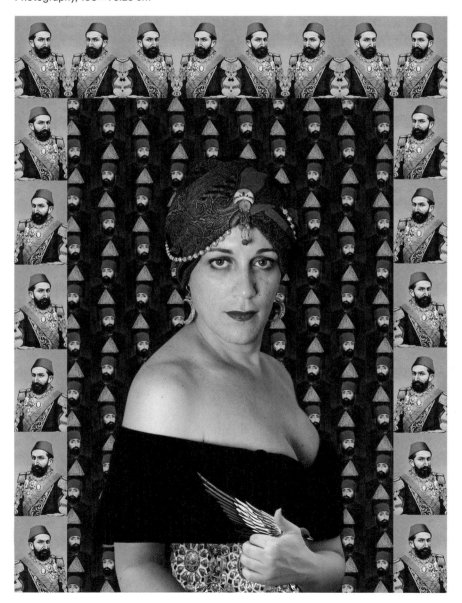

MAJED

Leila Aboulela

'What are you doing?' Hamid couldn't see her properly because he didn't have his glasses on. She was blurred over the kitchen sink, holding the bottle in her hand. She was not supposed to be holding that bottle. How did she get hold of it? He had hidden it behind the DVDs late last night. He had washed his glass carefully over the kitchen sink, gargled with ASDA Protect then crept into bed beside her, careful, very careful not to wake her or the two youngest ones. Majed slept in the cot in the corner of the room, the newborn baby slept with them in the double bed so that Ruqiyyah could feed her during the night. When Hamid had to go to the toilet he tried to be careful not to wake them up. Though sometimes he did, bumping into Majed's cot, stumbling on a toy. One night he had found himself, almost too late, not in the toilet but surrounded by the shoes that littered the entrance to the flat. He was startled into full consciousness by the baby crying.

'Ruqiyyah, what are you doing?' He should make a lunge at her, stop her before it was too late. It was precious stuff she was threatening to pour down the drain. But the whole household was in his way. A pile of washing waiting to go into the washing machine, the

baby, sunk down and small, in her seat on the floor. She was creamy and delicate, wearing tiny gloves so that she would not scratch herself. The kitchen table was in his way. Majed sat on his high chair covered in porridge, singing, banging the table with his spoon, Sarah talked to him and chewed toast. Robin scooped Rice Krispies into his mouth while staring at the box; Snap, Crackle and Pop flying and things you could send for if your parents gave you the money.

Ruqiyyah put the bottle down. But only because there were plates and baby bottles in the sink. She started to wash them up, water splashing everywhere.

She looked at Hamid and shook her head.

Hamid groaned. He was relieved he couldn't see her eyes, her blue eyes filled with tears maybe. She had not always been Ruqiyyah, she once was someone else with an ordinary name, a name a girl behind the counter in the Bank of Scotland might have. When she became Muslim she changed her name then left her husband. Robin and Sarah were not Hamid's children. Ruqiyyah had told Hamid horror stories about her previous marriage. She had left little out. When she went on about her ex-husband, Hamid felt shattered. He had never met Gavin, (who wanted nothing to do with Ruqiyyah, Robin and Sarah and had never so much as sent them a bean), but that man stalked Hamid's nightmares. Among Hamid's many fears, was the fear of Gavin storming the flat, shaking him until his glasses fell off, 'YOU FILTHY NIGGER, *STAY AWAY* FROM MY FAMILY.'

'Ruqiyyah wait, I'll get my glasses.' He looked at the children. He looked back at her, made a face. When the children finished their breakfast and headed towards Children's TV, they could talk. They couldn't talk in front of Robin. He was old enough to understand, pick up things. He was sensitive. Hamid ruffled Robin's hair,

said something jolly about Snap, Crackle and Pop. Robin smiled and this encouraged Hamid to be more jocular. Whenever Hamid was stressed, he changed into a clown. The hahaha of laughter covered problems. Hahaha had wheels, it was a skateboard to slide and escape on.

'I'll get my glasses.' He stumbled away. He needed the glasses. The glasses would give him confidence. He would be able to talk, explain. She was so good, so strong, because she was a convert. But he, he had been a Muslim all his life and was, it had to be said, relaxed about the whole thing. Wrong, yes it was wrong. He wasn't going to argue about that. Not with Ruqiyyah. Instead he would say... he would explain, that on the scale.... yes on the scale (he was a scientist after all and understood scales), on the scale of all the forbidden things, it was not really so wrong, so bad. There were worse, much worse, the heavies, the Big Ones; black magic, adultery, abusing your parents (something the dreadful Gavin had done – *pushed the old dear round her living room* – may he rot in Hell on account of this for all eternity and more). Hamid would explain... Once he put his glasses on and the world cleared up he would explain. Human weakness etc., and Allah is all-forgiving. That's right. Then a sad, comic face. A gentle hahaha. But she could counter that argument about forgiveness though. He must be careful. She would say that one has to repent first before one could be forgiven. And she would be right. Of course. Absolutely. He had every intention to repent. *Every* intention. But not now, not this minute, not today. A few more days, when he got himself sorted out, when this bottle was finished, when he finished his PhD, when he got a proper job and did not need to work evenings in ASDA.

He found his glasses near the bed between the baby lotion and the zinc and castor oil. He put them on and

felt better, more focused, more in control. Ruqiyyah hadn't yet dealt with this room. There were nappies on the floor, folded up and heavy. She had, though, stripped the sheets off Majed's cot. There were soft cartoon characters on the plastic mattress. Hamid rescued the prayer mat off the nappy-covered floor and dropped it on the unmade bed. He opened the window for the smells in the room to go out and fresh air to come in.

Outside was another grey day, brown leaves all over the pavements. A gush of rainy air, a moment of contemplation. *Subhan Allah*, who would have ever thought that he, Hamid, born and bred on the banks of the Blue Nile, would end up here with a Scottish wife, who was a better Muslim than he was. Why had he married her? Because of the residence visa, to solve his problem with the Home Office once and for all. A friend had approached him once after Friday prayers (he did sometimes go to the mosque for Friday prayers, he was not *so* useless), and told him about Ruqiyyah, how she was a new convert with two little ones, how she needed a husband to take care of her. And you Hamid, need a visa... Why not? Why not? Ha ha. Is she pretty? Ha ha. There had been a time in Hamid's life when the only white people he saw were on the cinema screen, now they would be under one roof. Why not? He brushed his teeth with enthusiasm, sprayed himself with Old Spice, armed himself with the jolly laugh and set out to meet the three of them. Robin's shy face, the gaze of a child once bitten twice shy. A woman of average height, with bright anxious blue eyes, her hair covered with a black scarf, very conservatively dressed, no make-up. He breathed a sigh of relief that she was not lean like European women tended to be. Instead she was soft like his own faraway mother, like a girl he had once longed for in the University of Khartoum, a girl who had been unattainable. And if on that first

meeting, Ruqiyyah's charms were deliberately hidden, they were obvious in her one-year old daughter. Sarah was all smiles and wavy yellow hair, stretching out her arms, wanting to be carried, wanting to be noticed. After the awkwardness of their first meeting, a lot of hahaha, tantrums from Robin, desperate jokes, Hamid stopped laughing. He entered that steady place under laughter. He fell in love with the three of them, their pale needy faces, the fires that were repressed in them. His need for a visa, her need for security, no longer seemed grasping or callous. They were swept along by the children, his own children coming along, tumbling out soon, easily. Two years ago Majed, three weeks ago the baby. At school when Ruqiyyah and Majed went to pick up Robin, no one believed that they were brothers. Ruqiyyah with her children; two Europeans, two Africans. The other mothers outside the school looked at her oddly, smiled too politely. But Ruqiyyah could handle the other mothers, she had been through much worse. She had once escaped Gavin to a Women's Refuge, lived with rats and Robin having a child's equivalent of a nervous break down. He must make it to the kitchen before she poured the Johnny Walker down the sink. He was angry. His secret was out and now that it was out it could not go back in again. It wasn't fair. If she was suspicious why hadn't she turned a blind eye, why had she searched for the proof? It wasn't fair. These were his private moments, late at night, all by himself, the children asleep, Ruqiyyah asleep. The whole soft sofa to himself, a glass of whisky in his hand, the television purring sights that held his attention, kung fu, football, Sumo wrestling, Amir Khan thrashing someone. Anything that blocked out the thesis, the humiliating hours spent mopping up ASDA's floor, the demanding, roving kids. Anything cheerful, not the news, definitely not the news. His own warm,

private moments, the little man on the bottle of Johnny Walker. That little man was Johnny, an average sort of guy and because he was walking, striding along with his top hat, he was a Walker, Johnny Walker. Or perhaps because he *was* Johnny Walker, he was represented as walking, striding along happily. It was interesting, but at the end it didn't matter and that was what Hamid wanted at that time of night. Things that didn't matter. At times he took his glasses off, let the television become a blur, and he would become a blur too, a hazy, warm, lovable blur. Nothing sharp, nothing definite. Blurring things made them tolerable, made it possible to get by. The exact number of years he had been a PhD student. Don't count, man, don't count. Laughter blurred things too. Hahaha. His thesis was not going to make it. He must, his supervisor said, *stretch himself*. His thesis now, as it stood, was *not meaty enough*. There was a lot of meat in ASDA, shelves. When he cleaned underneath them, he shivered from the cold. Not meaty enough. Johnny Walker was slight and not at all meaty and he was alright, successful, striding along brimming with confidence. Why shouldn't a man with an unfinished thesis and an ego-bashing job at ASDA sit up late at night, once in a while, settle down in front of the television and sink in. Sink into the warmth of the whiskey and the froth of the TV. Once in a while?

Majed lunged into the room. He squealed when he saw Hamid sitting on the bed. 'Majed, say *salaam*, shake hands.' Hamid held his hand out. Majed took his fist out of his mouth and placed it, covered in saliva, in his father's hand. Then he pointed to his cot, transformed because the sheet wasn't on it. It wasn't often that Ruqiyyah changed the sheets. Majed walked over to his cot mumbling exclamations of surprise. He put his hands through the bars and patted the cartoon characters on the

plastic mattress. 'Mummy's washing your sheet. You'll be getting a nice clean sheet,' Hamid said. It was rare that the two of them were alone together. Hamid held him up and hugged him, put him on his lap. He loved him so much. He loved his smell and roundness, his tight little curls and wide forehead. Majed was a piece of him, a purer piece of him. And that love was a secret because it was not the same love he felt for Robin and Sarah. He feared for Majed, throat-catching fear, while with Sarah and Robin he was calm and sensible. He dreamt about Majed. Majed crushed under a bus and Hamid roaring from the pain, that came from deep inside, that surfaced into sobs, then Ruqiyyah's voice, her hand on his cheeks, what's wrong, what's the matter and the wave of shame with the silent coolness of waking up. I'm sorry, I'm sorry, it's nothing, go back to sleep. The more he loved Majed and the new-born baby, the kinder Hamid was to Robin and Sarah. He must not be unjust. Ruqiyyah must never feel that he favoured their children over Robin and Sarah. It was a rare, precious moment when he was alone with Majed, no one watching them. He threw him up in the air and Majed squealed and laughed. He stood Majed on the bed and let him run, jump, fly from the bed into his outstretched arms. Then he remembered Ruqiyyah in the kitchen. The memory dampened the fun. He sent Majed off to join Sarah and Robin in front of the television and he walked back to the kitchen.

Ruqiyyah was clearing the things off the kitchen table, the baby was asleep in her chair on the floor. With his glasses on now, Hamid could clearly see the whisky bottle. Two thirds empty, two thirds... His heart sank, that much... or had she already poured some out? No. No she hadn't. He knew what she was going to do. She was going to clear the kitchen, wash everything and put it away, then ceremoniously tip the bottle into the empty sink.

She started cleaning up Majed's high-chair. Her hair fell over her eyes. She wore an apron with Bugs Bunny on it. She was beautiful, not like women on TV, but with looks that would have been appreciated in another part of the world, in another century. Her lips were naturally red. He had thought, before they got married, that she was wearing lipstick. She wore *hijab* when she went out, she got up at dawn and prayed. This seriousness that he didn't have, baffled him. Something Scottish she brought with her when she stepped into Islam. The story of her conversion amazed him as much her stories about Gavin shocked and sickened him. She had read books about Islam. Books Gavin had snatched and torn up. Not because they were about Islam, but because she was sitting on her fat arse reading instead of doing what he wanted her to do.

She wanted to learn Arabic. Hamid would doze in bed and next to him she would hold *Simple Words in Arabic*, over the head of the baby she was feeding. 'How do you say this?', she would ask from time to time, nudging him awake. When Hamid read Qur'an out loud (he went through religious spells in Ramadan and whenever one of the children fell ill), she said, 'I wish I could read like you.'

He started to help her tidy up. He closed the flaps on the box of Rice Krispies, put it away in the cupboard. When she finished wiping the table and started on the floor, he lifted up the baby's seat and put it on the table. If she would talk to him, shout at him it would be better. Instead he was getting this silent treatment. He began to feel impatient. What had made her search for the bottle? A smell...?

Attack is the best form of defense. Laughter blurs things, smoothes them over. Hahaha. He began to talk, he put on his most endearing voice, tried a joke. Hahaha.

She didn't answer him, didn't smile. She pushed her hair away from her face, poured powder into the drawer of the washing machine. She bent down and began to load the washing into the machine. It was linen, the sheets that had been on Majed's cot. Hamid said, 'But how did you know? Tell me.'

She sat on her heels, closed the door of the washing machine. She said, 'You pissed in Majed's cot. You thought you were in the toilet.' She twisted the dial that started the wash cycle, 'I pretended to be asleep. He didn't wake up.'

There is a place under laughter, under the hahaha.

Hamid saw her stand up, pick up the Johnny Walker and pour what was left of it down the drain. She poured it carefully so that not a single drop splashed on the sink where later the children's bowls and bottles would wait to be washed.

WHITE LIKE ME

JENNIFER JAJEH

IT'S JUNIOR YEAR OF HIGH SCHOOL and I'm sitting out in the open air courtyard with my best friend Amy DeAmicis. We're comparing notes about what happened to us over summer break as we keep an eye out for Amy's crush, Drew. My crush, the impossibly beautiful Kevin Lessig, transferred that year to finish high school in Colorado or maybe Washington, some place that sounded distant, rural and white. My interactions with Kevin had been less than fruitful, consisting of him trying to chat me up in French class while I lost all ability to produce coherent sentences in his other-worldly presence. In my head, he was solar systems out of my league.

If our lives were the Breakfast Club, Amy would be Molly Ringwald and I'd be Ally Sheedy, just way more preppy and with a lot less eyeliner. The made-over Ally Sheedy at the end of the movie; outside all Guess jeans and Esprit sweatshirts, but inside all darkness, emo and angst.

'I don't really feel like I fit in.'

'What do you mean?'

'I'm, well... I'm just not like everybody else.'

'Why? Because you didn't go to elementary school with us?'

'No..'

'Well, why then?'

'I just feel... different.'

'Jenni, what do you mean you feel different?'

'I don't know. Just forget it.'

'Because you have a huge family?'

'No.'

'Because you live in a smurf blue house?'

'I mean, yeah, but that's not it.'

My mother always had what I like to call interesting taste. Exhibit A: the smurf blue house. Exhibit B: her ever present, super long, glittery purple fingernails. I

would later learn that it was just being Palestinian, but at the time it felt like she had taken out a deeply personal vendetta to embarrass me with her flamboyance as often as possible.

'It's. Well it's just… Well, you know. I'm not. I'm not… white.'

'Jenni, of course you're white.' Amy replies, amusedly, as though addressing a child.

'No. I'm not.'

'Yes, you are. I think of you as white.'

'You do?'

'Everyone does. You're white,' she says definitively, as if the conversation is now closed.

Amy isn't like any of the girls I grew up with. She lives in an affluent part of town in an impeccably-kept home. When Amy turned sixteen, her mum took her to get her 'colours done' so that she would always know the most complementary shades of makeup and clothing to wear. The following week, she came to school in a head-to-toe pumpkin orange ensemble and gobs of rust coloured eye shadow. Apparently Amy is a 'Fall.' She guesses I'm a 'Winter,' but this is all pre-internet and cannot be easily verified. I flounder my way through the rest of high school in a sea of decidedly un-wintery yellow turtlenecks and green Gap hand-me-down sweaters.

After school, I take the bus home in the opposite direction to my friends. None of them have ever been to my neighborhood or could even point it out on a map. Being one of seven kids, our compact house is stuffed to overflowing with pets, people and our innumerable belongings. The combination of my two harried parents desperately scrambling to keep a house of nine in order while negotiating an unraveling arranged marriage means that keeping us dressed, fed, and unharmed is the

best they can possibly manage. No one will ever take me to get my colours done.

Despite all of our differences, Amy and I are inseparable; it's (white) me and (white) Amy against the world. Although to be honest, this isn't the outcome I was expecting. In my mind, she'd comfort me for not being white and come to understand and even empathise with the challenges of my non-whiteness, all while reiterating our undying best friend bond. I had only envisioned the conversation going this way, and am now unsure how to recover after her entirely unexpected assurances of my whiteness.

Was she right? Was I white? I was highly skeptical.

This issue is raised again mere months later when it comes time to fill out college applications. I'm doing fine until I come to the portion on self-identifying for ethnicity:

1. **Are you Hispanic/Latino?**
 - ☐ Yes, Hispanic or Latino (including Spain)
 - ☐ No

2. **Regardless of your answer to the prior question, please indicate how you identify yourself. (Check one or more and describe your background.)**
 - ☐ American Indian or Alaska Native (including all Original Peoples of the Americas)
 - ☐ Asian (including Indian subcontinent and Philippines)
 - ☐ Black or African American (including Africa and Caribbean)
 - ☐ Native Hawaiian or Other Pacific Islander (Original Peoples)
 - ☐ White (including Middle Eastern)

Scanning the options, I get to the bottom of the form and can't believe my eyes:

☐ White (including Middle Eastern)?

WHITE? INCLUDING? MIDDLE? EASTERN?

My teenage mind is blown. White? We're really *white*? How has this been kept from me for the first sixteen years of my life? My parents have always drilled it into my head that we aren't like the *Amercan* (layman's term for white). We are different. We are Palestinian and proud. So how are we white all of a sudden? This did not compute.

I feel duped and totally lame. Even white Amy knew I was white before I did. I'd wasted so many years feeling different when all along I was WHITE? What a waste of a persecution complex! And what about those jerks in elementary school teasing me for so many years for being an Ay-rab? Instead of fighting back or concocting appropriately offensive racial slurs in return, I could have just coolly told them that I was actually white and let the insults roll right off my milky white back.

The summer after college, my high school friend Alex (who I incidentally meet through Amy) invites me to share the *chambre de bonne* in her friend Aude's massive family flat in the 9th arrondissment. Suffering from the unexpected death of my father, an influx of inheritance money and a need to suppress any real feelings with as much travel, alcohol and hooking up as possible, I'm unable to resist the lure of such an invite.

The transition to Parisian life is not a seamless one. My perfect grades in high school French don't translate into easy conversational skills and I'm unable to follow much of what people are saying. I imagine the repressed grief and heavy drinking have a fair bit to do with my inability to mesh with our new French friends. It also doesn't help that Aude acts as if everything I say is un-couth and idiotic, i.e. *très Americain*, or that Alex has a penchant for daily weed smoking and doesn't feel right unless everyone around her is stoned.

Life functions at a normal routine of boat parties on the Seine, annoying French misunderstandings and lots of *tartes à la tomate* until one afternoon, when we receive an unexpected and very urgent knock at the door from the French police. Romain, Aude's lanky stoner boyfriend, confesses to us all later that evening that a very large quantity of pot has been shipped to our flat in Alex's name. The household immediately goes into damage control, scrubbing away any and all traces of illicitness, but it's clear this is an unnecessary measure when the police show up the next day at Alex's work. I've had enough. I wish Alex luck and pack my bags for Amsterdam.

Gare du Nord. Leaving the Frenchies and their bad juju behind, I feel giddy, unburdened and finally back to myself. Here I am a vibrant and clever girl embarking on a brand new phase in an epic European adventure. My plan is simple: get to Amsterdam in time to celebrate my twenty fourth birthday and leave all of this darkness behind in Paris. I have time for a cigarette so I flirtatiously ask the man sitting next to me to watch my bag as I step outside to smoke, certain my luck is changing.

As I return to the station minutes later, it's obvious that something has gone awry in my absence. I become aware of a group of French policemen running towards

me shouting in indecipherable French. My French classes have failed me yet again.

It dawns on me that this could be a very bad situation; that perhaps Alex or the flatmates have framed me, and I start to panic. The police point in the direction of my bag, which is lying alone on the floor in the middle of the station, while they continue rapid-fire-yelling at me. All the cockiness of a moment ago drains right out of me. No matter how cute I think I am, I'm certain that I'm headed to jail for an international drug debacle that I had no part in. After what seems like hours, it finally becomes apparent to them that I have no idea what they're yelling at me, and one of them confirms that I am in fact American.

'*Oui, oui, Americaine et mon Français n'est pas bien.*' I've never wished to be as American as I did in this moment.

They slow down and switch to broken English. One of them grabs me and asks if I'm arabe. I play it safe and stick to the American story. He insists I look Arab, which I find amusing since no one has ever thinks I look Arab. Not even Arabs. I've been mistaken for Mexican most of my life.

He interrupts this tangential musing by asking me what is in my bag.

'*Bombes?*', he yell-spits in my face.

'Bombs?', I ask incredulously.

'*Bombes*', he says again with force.

It's at this point that I notice a team of officers stationed at a tactical distance from us and the reality of the bomb question begins to play out in my mind. They thought I had a bomb. They were isolating my bag, ready to detonate it. They were going to blow up my bag.

I had crossed the ocean hoping the French would be blowing up my panties, but this was most definitely not how I imagined it happening.

One of the officers drags me over to my bag, and asks me to open it. I'm unclear about the request, so he pulls me down to the floor with him as he unzips the front panel of my bag.

'What's in here?', he demands.

Just my clothes I tell him in my halting Frenglish. After unpacking enough dirty laundry to satisfy everyone that I am not packing a bomb, he commands me to repack my own bag. Like a scolding dad, he begins to chide me for being so ignorant.

'*Ne laisse jamais ton sac*. Never leave your bag. Don't you know that? You can't leave your bags when you look like that. People plant bombs. Arabs plant bombs. How do you not know this? There are terrorists. People who leave bags in train stations. You're lucky we didn't blow up your bag.'

And just like that I went from fleeing an international drug trafficking incident to becoming a potential terrorist threat. That night I celebrated my birthday with a whole new group of friends in Amsterdam, and for the time being I let it all roll right off my milky white back.

Tuesday's Child

Hassan Abdulrazzak

TWO THINGS I DID NOT ANTICIPATE that tuesday morning: the terrorist attack and the subsequent loss of my sanity.

I am awakened at ten to nine by a phone call from my mother. I hear her voice crystal clear all the way from London:

'Are you in New York?!'

'Mum, why would I be in New York? You know I live in Boston.'

'Just answer me, are you in New York?'

'No. What's got into you?'

She tells me to turn on the TV. I do. And there it is: the North tower of the World Trade Centre looking like an out-of-control chimney. My morning brain, still groggy from sleep, struggles to process what's going on. Mum tells me a plane went into the tower by accident. I guess she intuitively senses there is a chance this is no accident. Even though I find our conversation ridiculous (why would I go to New York in the middle of a working week?), I still reassure her that I will stay away from the Big Apple.

I arrive at the Massachusetts General Hospital at the Navy Yard in Charlestown where I work. This institution is part of Harvard University and houses labs by world renowned biologists. Every scientist worth his salt dreams of coming here. The lab where I work is open plan. It looks like a huge factory floor with lab benches going back as far as the eye can see. Normally it's buzzing with activity as scientists from all over the world carry out cutting edge experiments. But today all is silent. Only a handful of people

are getting on with work. Instead, almost the whole department is huddled in the common room where we usually eat our lunch. Everyone's eyes are glued to the TV screen in the corner. The pentagon has been attacked. Both twin towers have collapsed. There are huge clouds of pulverised concrete engulfing downtown New York. People are covered in thick white dust, making them resemble extras in a zombie apocalypse movie. There is no doubt now that this is a terrorist attack.

The news cuts to police officers running down a train platform. The cameraman is struggling to keep up with them. They are chasing a suspect. We see the police pounce on someone and pin him down. 'The cops appear to be apprehending a *Muz-lem*', says one of the news anchors. I look at the man's turban and realise the police and the anchor have made a huge mistake. I want to shout at the TV, 'You idiots, the man is clearly a Sikh!' I am apprehensive to say this in front of my colleagues who watch the screen with intense silence.

An American colleague in her forties turns to me and asks very loudly, 'So Hassan, can you explain Hamas to me?' I feel all eyes are on me now. The room rapidly shrinks. I'm like Joseph K in Kafka's *The Trial*, not quite sure what I am being accused of. I mumble something about Palestine and the occupation. My colleague looks disinterested. 'Yes, but why do they kill people?', she insists. This woman is a specialist in electron microscopy. She holds in her head the most complex theories about sub-cellular particles yet when it comes to world politics she is like a clueless giant baby who has suddenly woken up in a bad mood. She isn't alone. The question 'Why do they hate us?' is asked by a lot of pundit babies over the coming weeks. Those who dare to provide the correct answer are often viciously vilified.

Later that afternoon I walk over to the far end of the lab where my friend, Jaafar, a burly, super hairy Lebanese sits. Jaafar had recently graduated from the American University of Beirut with a degree in medicine. Coming to America was his first chance to live outside of the Middle East and he was still adjusting to the

culture shock, particularly as he came from a conservative Shia family. You could often hear his booming laughter reverberating through the lab. It was not unusual to walk past his desk and see him browsing soft porn websites in between experiments without an ounce of embarrassment. I tried to explain to him how disrespectful his behaviour was to our female colleagues and that he was reinforcing a negative stereotype about Middle Eastern men, but he would just laugh and grab me in a headlock.

When I walk over to Jaafar I am hoping his mirth will provide a welcome relief from the tense atmosphere. He is absorbed in looking at a webpage.

'Hey Jaafar. What are you up to?'

'I'm seeing what the *hizb* (party) is saying about this attack.'

I look over his shoulder and see the page he is browsing. I freeze with alarm.

'Are you nuts? You're seriously looking at Hezbollah's website today of all days?'

'Why not?', he says with almost adorable innocence.

'Because the university computers are monitored. And someone looking at a terrorist website—'

'Hezbollah are not terrorists', he interrupts.

'Today is not the day to get into that debate. Please, just close the page.'

'I don't see why I should.'

'Jaafar, do me a favour. Go back to looking at porn. It's much safer.'

The day has passed in a surrealist blur and now it's evening and a bunch of us Arab scientists head to Harvard Square. When we arrive, we notice a heavy police presence. We meet Aymen, a young Egyptian student. Aymen goes into a tirade against American imperialism. We ask him to keep his voice down. He ignores us. We walk into our favourite tavern on the square. There we overhear heated conversations going on all around us. 'We should bomb them back to the stone age', one guy shouts loudly. It's not clear who the 'them' are. You can feel the American male

testosterone bouncing off the tavern walls. Dudes want revenge and they want it now.

It's on the next day, Wednesday, when I'm walking towards the subway that I notice the mushrooming of flags. Of course many of the houses on my street were adorned with the flag prior to 9/11. Today they all seem to have taken the practice to a whole new level. It is as if there was a competition overnight to see who could have the most and biggest flags on display. The winner is a three storey house which has a flag that covers the entire front from rooftop to ground. How do you even get hold of such a giant flag on short notice?

I then see a black pickup truck drive by with the message 'All Muslims must die now!' written in white paint along the side. I am so shocked by this that I wonder whether I have imagined it. This is too much for someone like me, a *Guardian* reader from Surrey. It's not as if I had not witnessed or experienced racism in Britain. I had. But having grown up in a leafy suburb, I was sheltered from the worst of it. I try to picture that man's morning. He woke up, had breakfast with his family then told his wife:

'Honey, I'm just going out the back to paint 'All Muslims must die now!' on the side of the truck.'

'You do that sweetheart. And don't forget your packed lunch.'

In the evening, my friends and I head to Harvard Square again where we see Aymen standing with a group of Americans, holding a vigil candle. Makram gently teases him about his U-turn. Aymen looks away. I see fear in his eyes.

* * *

Over the course of the following weeks and in the aftermath of the attack on the twin towers, I become obsessed with science and politics. When I'm not reading complex scientific literature, I devour books by Tariq Ali and Edward Said. I attend a talk by Noam Chomsky at MIT. I get into an email argument with Richard Dawkins after he publishes an article about the attack in

The Guardian. He puts the blame squarely on religion. I argue that political grievances are a more important factor.

There is now talk of a war on terror. My own country of origin, Iraq, is mentioned as a possible target. Dhafer, my intellectual scientist friend, is dismissive of my certainty that we will be attacked.

'But that's crazy, everyone knows Saddam and Al-Qaeda hate each other.'

'It doesn't matter, Dhafer,' I argue. 'The US has just been slapped across the face and needs to show its might to stop something like this happening again.'

Our friend Makram is torn between us. 'Hassan could be right. They've started bombing Afghanistan, but what's in Afghanistan? Soon they'll run out of targets. On the other hand, surely the world community will step in to stop a war against Iraq.'

We begin to tire of having these conversations. Yet somehow it seems impossible to go back to debating the merits of Oum Kalthoum.

Makram departs to Tunisia for an extended holiday. Dhafer and Jaafar are reluctant to go out now. All of us push ahead with our research, perhaps secretly fearing we might get deported before completing our work. I have discovered an unusual DNA structure in a gene vital for health. My boss is excited by the finding and praises me when I present the data at a departmental meeting. But is this result a test tube artefact or have I stumbled on a hitherto unknown mechanism of how genes function? I push myself to the limit trying to find the answer. I hit a brick wall. For the first time since arriving at Harvard, I'm not sure of my next chess move. My thoughts race out of control. The combination of hard science and endless news about war and terror trigger something in my brain.

What if there is a biological explanation to what is happening in the world.

Click

What if underlying this conflict between East and West is an evolutionary struggle.

Click Click

I go up to Claude, a super smart French postdoc in our lab. I jot on a piece of paper a diagram to illustrate my theory about the evolutionary underpinnings of 9/11. Claude looks at me with puzzled concern. 'Stop reading all that Dawkins crap,' he advises. Other members of the department eye me suspiciously as they notice I have taken to walking aimlessly around the lab, lost in thought.

Click Click Click Click

If you combine Foucault with Edward Said with Bernard Lewis with Richard Dawkins, it becomes clear, does it not, that this struggle between East and West is just a way to create evolutionary pressure and mix human genes.

Click Click Click Click Click Click Click

I pressure Dhafer to take time out of work and meet me in a cafe where I struggle to explain to him my theory. He looks at me with a bemused look, not comprehending what I am saying.

Click Click Click Click Click Click Click Click Click Click Click Click

BOOM.

I jot down on the back of an envelope the following sentence:
'For evolution to be true we must all be telling the truth.'

This phrase makes perfect sense to me at this moment. I am convinced it is the ultimate axiom. Once you discover this truth, the world comes to an end. I'm totally convinced that I am the last man left on earth. I feel the terror of that pitch-black loneliness. But then the feeling subsides and I remember I share my flat with my Haitian flatmate.

I knock loudly on his bedroom door. He's making love to his girlfriend. 'Michael open up!', I shout. I hear him cursing and despite having gone mad, a rational part of my brain tells me interrupting his love making is probably not a good idea. But the clicking part of my brain says that once I share my 9/11 evolutionary theory with him, he's going to be so happy and become my first disciple. Michael opens the door. He's mad as hell, but once he sees the wild

look on my face, his expression changes to concern. I start ranting about how I am the new prophet, set to guide humanity out of this endless torment of war and conflict by hacking evolution. I say something about Bono being the equivalent of a Medici prince and how he will help me spread my ideas once I get in touch with him. Michael and his girlfriend listen, wide eyed. They ask me to give them the number of a next of kin to contact. I try to search my pockets and realise I am standing in their room with nothing on except my underpants.

I am plagued with images of evolutionary hell: I picture bombs falling over Afghanistan and Iraq. Many are killed. The survivors are then subjected to an evolutionary pressure. The smart, the resilient, the resourceful make the perilous journey to Europe or America. The dull of mind and disabled of body are left behind. The ones who make it to the West mix their 'good' genes with the native population, thereby enriching it. If this repeats over and over, will the world not divide into two species of humans? Pockets of superiors and pockets of inferiors? Is hell then just a metaphor for this evolutionary reality that underpins our every-day world?

I'm put on a plane and sent back home to my parents. I'm weeping uncontrollably as I go over and over my visions of hell. The stewardess upgrades me to an isolated first class seat so I don't frighten the other passengers. In London, I'm diagnosed with having suffered a psychotic episode brought on by stress. The old fashioned term for such a state is 'nervous breakdown'. I am advised not to go back to America.

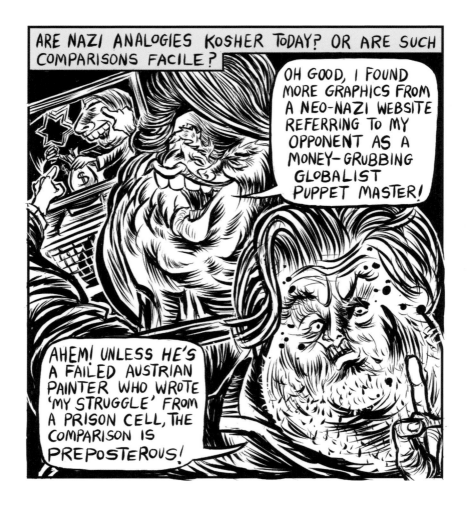

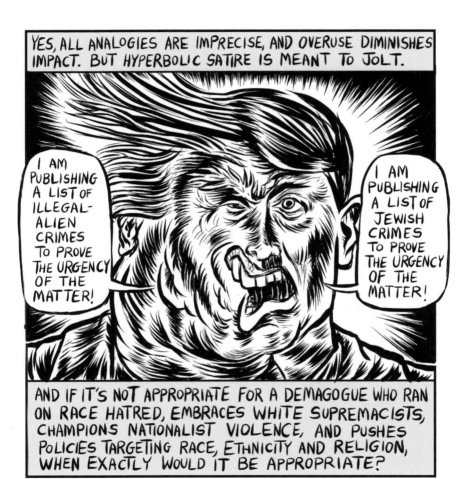

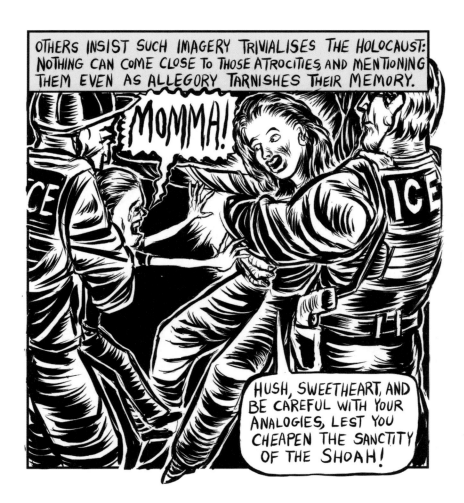

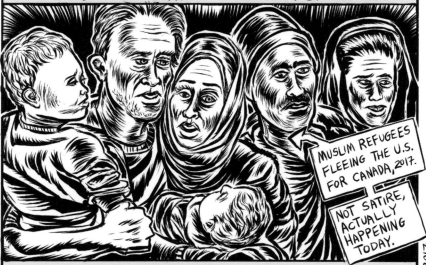

BUT MAKING THE HOLOCAUST UNTOUCHABLY SACROSANCT DIMINISHES THE VERY HUMAN DIMENSIONS OF ITS HORROR. AS HISTORIAN YEHUDA BAUER WROTE, 'THE WARNING CONTAINED IN THE HOLOCAUST IS SURELY THAT THE ACTS OF THE PERPETRATORS MIGHT BE REPEATED, UNDER CERTAIN CONDITIONS, BY ANYONE.'

MUSLIM REFUGEES FLEEING THE U.S. FOR CANADA, 2017.

NOT SATIRE, ACTUALLY HAPPENING TODAY.

IF EVER THERE WAS A TIME TO APPLY THE ULTIMATE ANALOGY OF ETHNIC HATRED TO ENSURE 'NEVER AGAIN' IS NOT JUST A PLATITUDE, THE TIME IS NOW, AND IT IS RUNNING OUT.

Of DOLPHIN CHILDREN *and* LEVIATHANS

MORIS FARHI

FROM THE OBSERVATION TERRACE of Galata Tower, the Genovese citadel that dates back to 1348, Istanbul stretches out before me.

Yesterday, down in the square, I fled from the Saviours.

Today I've come for my valediction.

I'm resolute.

But in case I falter, I think back.

Childhood is seldom idyllic. Childhood spent in children's homes is desolation.

Yet desolation can be a blessing. It drives the child to seek answers.

At first, it raises elementary questions: why did my parents abandon me? Did they hate me? Were they destitute and unable to feed me? Did they just die? Were they killed because they believed in goodness? Were they killed trying to protect me?

Then other questions stream – questions that demand meanings to existence. Often the process awakens that faculty which the Leviathans call apple *after the fruit of the Tree of the Knowledge of Good and Evil.*

I watch as the Saviours' paramilitaries comb the area around the Tower. Still salivating from yesterday's spoil, they're ravenous for the one they anticipate today.

They'll have it.

The apple is our guiding soul. It reveals to us all that is good, all that affirms life; and it warns us about all that is evil, all that unleashes death before life can be completed.

That's why the Saviours, false prophets and megalomaniac leaders, denature everything that is beatific. That's why they feed us the fiction that God singled out the apple *as the forbidden fruit and banished Adam and Eve from Eden for eating it.*

I shout at the Saviours' paramilitaries: 'I'm back!'

They spot me and regroup.

It's the Saviours who keep brainwashing us with the lie that God ordained them to redeem our wickedness by making us spit out even those bites taken by our primogenitors. For they know that when we finally eat every morsel of the apple *we shall transmute into love the inhumanity they have imposed on us as the ultimate morality.*

And one day we shall have eaten every morsel of the apple. *The Leviathans will see to that. Much as the Saviours scorn the Leviathans or depict them as 'false messiahs', they can't stop them. The Leviathans are Eternal.*

I imbibe Istanbul.

Conjoining Europe and Asia with seven hills, two seas and the princely Bosporus, it inspires earth, water, sky and fire to unfurl radiances unseen anywhere in the world.

Sofi used to say: 'Life is everlasting. Death is not. That's what Istanbul tells us.'

Sofi nurtured in her marrow the ration of the apple she inherited from Eve.

We were thirteen. Vegetating in dingy institutions. We might never have met but for a charity function organised by some Istanbul worthies offering a circumcision kermis to my orphanage and a girls' picnic to Sofi's. To save money both events were held at the same venue, a humble open-air café on the heights of Büyük Ada, Istanbul's largest island.

Eventually, bored with the vanilla merrymaking, we both slipped away from our groups and made for the cliffs. Scurrying between boulders, we didn't see each other.

Sighting an isolated beach below, we picked our separate ways down the scar and reached it almost at the same time.

It was Fate, of course, who brought us together. But it was also Fate who had woven our orphan's barbed shirt.

Hesitant to trust Fate, we stood about warily.

Sofi spoke first. 'Escaping the circumciser?' Her voice had the dulcet tones of the oud.

I muttered. 'I was done last year. Just escaping.'

'Me, too – escaping...' She laughed. 'Though not from the circumciser...'
Her candour captivated me. I laughed, too.
She drew near. 'I'm Sofi. A-la-franca name. Means "wise". I'm told I'm
not from some minority but a Turk. As if that makes any difference...'
Our eyes engaged.
I gushed. 'Who cares what you are?'
'Actually, I love minorities. They're wiser because they're always dis-
criminated as "others". I wouldn't mind being one.'
I held her hand. 'Whoever you are – you're heavenly!'
She didn't withdraw her hand. 'And who're you?'
'Ragip. Probably Gypsy – that's what the orphanage thinks. My dark
skin...'
She squeezed my hand. 'You're heavenly, too!'
This Fate was not the one who wove barbed shirts. This Fate had come
bearing gifts.
Emboldened, I hugged Sofi.
She whispered. 'Let's swim.'
I hesitated. 'We don't have bathing suits.'
She laughed and undressed. 'Nor do fish.'
'They'll be looking for us.'
'They'll never find us.'

Our Leviathan often jested: 'You two met like turtles. But in reverse
order. You started on a shore where you could lay eggs. Then mated
in the sea.'

We swam, saltating like flying fish.
We encountered eddies, strong, inquisitional, as if wanting to know
whether we were friend or foe.
We whirled with them and became trusted playmates.
We raced to a distant crag.
We discovered a grotto concealed by algae and thick moss.
We slipped in.
It was deep and oval.
The water, azure and luminous, purled gently.

'Like my grotto – your Heaven,' Sofi would say after we became lovers.

We climbed onto a ledge.
She whispered: 'Listen to the aether.'
I listened, but didn't hear anything.

I soon learned that the aether's euphony descants Creation's wonders. As with the morsel of *apple*, it's a boon we receive at birth. The Saviours strive to despoil that, too. For them wonders are dangerous.

When we finally got back to the café, the festivities had ended. Our orphanages, no doubt assuming we had run away, had returned to Istanbul.
 Sofi and I became one.
 We made the grotto our home.
 We lived on fish – easy to catch – and on fruits and vegetables we foraged.
 In winter, we built a shelter with the rocks strewn on the cliffs.

Our Leviathan praised us for that: 'You lived like Diogenes, shunning shadows.'

Our Leviathan...
 He wafted into the grotto in a sea-mist.
 Sofi and I had just made love and were ebbing in the water.
 Sofi saw him immediately and greeted him. 'Welcome – whoever you are!'
 A voice, clear like spring water, answered. 'A Leviathan.'
 Then, as he emerged from the mist, I saw him. He was a colossus with a human build. He had an earnest, smiling face that looked familiar – in fact, he could have been the twin of our hero, Hrant Dink. A blue aura – the transcendent blue that can only be seen in Istanbul – girdled his body. And he glowed as if he had the sun in his insides.

He sat on the ledge. 'I've been watching you.'

Sofi challenged him with her glittering smile. 'You couldn't have. We'd have seen you!'

'I can be invisible.'

'Not with your size!'

'I can also change shape. I can turn into a jutting rock or a strand of seaweed.'

Sofi laughed. 'Or a horse or a whale or an eagle.'

He smiled. 'Easily. But I prefer the human form.'

To prove his point he reduced his size and shrank from a giant to a man's average height.

Sofi, though impressed, remained unruffled. 'Why were you watching us?'

'To be sure you're Dolphin Children. You, Sofi, you definitely are.'

Sofi clapped her hands. 'Really? Wonderful! I love dolphins!'

He turned and touched my shoulder. His hands had the softness of the loving father that sings songs in every orphan's dreams. 'You're becoming one – absorbing her spirit.'

I gawked at him and wished that he really were my father, back from the darkness that had penned him since my birth.

I managed to stammer. 'What do you mean – Dolphin Children?'

'Apple souls. Sent from the Heavens to traverse lands, seas, skies and fire to repair the world.'

Sofi became excited. 'Repair the world?'

He sighed. 'There are great perils ahead for humanity and the planet. There's much to be done. I've come to guide you.'

Sofi answered without hesitation: 'I'm ready.'

Confounded as I was, I echoed Sofi. 'Me, too!'

Sofi held his hand: 'Now tell us – who are you really?'

He stroked her hand. 'I told you: a Leviathan. But I was a Dolphin Child once – like you. An orphan, too. Now I am an Eternal. That's what Dolphin Children become when they're killed. We, Leviathans, go all over the world to find Dolphin Children and mentor them. We disclose humankind's history – the real history or rather what was ordained to be the real history, not what the Saviours have fabricated. We mould

the Dolphin Children as the upholders of Goodness, as the emissaries
of peace, as the voices of life. And, even as we warn them about the
countless ambushes that await them, we lament that there'll always be
one ambush that'll kill them.'

Sofi acclaimed. 'I should have guessed. You're Hrant Dink!'
The Leviathan looked surprised. 'What makes you say that?'
'I have eyes that can see.'
I, *echoed Sofi. 'Yes! Hrant Dink! I thought you looked like him when*
I first saw you!'
The Leviathan's eyes turned misty. 'If you say so...'

Actually Leviathans seldom use their names. They don't have to;
they're easily recognised by those who immediately feel the sorrows
they carry. Sofi – and, by her grace, I – possessed that perception.
And Sofi being Sofi, did coax our Leviathan to admit that indeed
he had been Hrant Dink in his Dolphin Child days. Some may
have forgotten Hrant Dink or don't know who he was. Suffice it to
say he was one of a handful of Just Beings who had tried to repair
the world. For that, he was assassinated – a few years back – in our
beloved Istanbul. Sofi and I never stopped idolising him.

In due course, Hrant told us how he became a Leviathan. When
the Saviours captured him in his Dolphin Children days, they
asked him: 'What makes you juvenile malcontents so special?' 'The
apple, the knowledge of Good and Evil,' he told them. The Saviours
mocked him: 'Fat lot of use that is!' 'Oh, it's of great use,' Hrant
responded, 'it makes us fearless.' The Saviours sniggered: 'Are you
telling us – shackled and at our mercy as you are – that you're not
afraid?' 'Of course, I'm afraid,' Hrant conceded, 'but I'm also fearless.'
'We don't believe you,' jeered the Saviours. Hrant shrugged. 'That's
because you rule by fear and see how it paralyses people. But we,
Dolphin Children, know more than you what fear is. That's why
we make ourselves fearless. More importantly, you, the Saviours,
force yourselves to believe that fear is invincible. You put all your
trust in it. You acclaim it as an infallible weapon. But, I'm sure you
know, deep down, that fear is not really invincible, that it can be

defeated by fearlessness, that, in fact, fearlessness is the only element that, sooner or later, will defeat fear – and you. So you spiral into madness. And, like the proverbial drowning man who grabs a crocodile to save himself, you cling to fear in total desperation.'

The Saviours, perturbed by the way Hrant had read their minds, grew agitated. They decided that if the masses were to sniff even a whiff of his portent, their androcentric world order would collapse. So with their customary practice of silencing those who speak the truth, they slaughtered him.

The grotto became our forum.
Hrant enlightened us.

'As the poet, Al-Maari – another Leviathan – has instructed us, history has been kidnapped by two rival species of Saviours. One with brains but no persuasion; the other with persuasion but no brains. Inevitably, their rivalry unleashed endless conflicts. People, if not dispatched as weapon-fodder, suffered pillage, rape, famine, and deportations. Even the few who managed to escape and find a cranny where they could dream and survive, perished – alone and forgotten, earthless and dreamless.

Yet, as they drew their last breath, the people gazed at the world and marveled at the beauty and benevolence it had offered them since the beginning of time. And they prayed that one day both species of Saviours would wither and that humanity, thus freed, would attain the life that is its birthright: love, freedom, equality, happiness and, not least, natural death.

Countless writers, artists, thinkers, scientists, healers – all of them Dolphin Children who became Leviathans – endeavoured to claim this birthright.

Occasionally, they confounded the Saviours and produced a Golden Age here and there.

But for every Golden Age the Saviours forged a new strategy. They invented faiths and ideologies, cults and rituals, sins and transgressions. They devised horrendous punishments for any dissidence, any

unorthodoxy and any otherness. They dismissed the achievements in philosophy, arts and sciences as treacherous mirages. Those without persuasion exalted their brains and those without brains exalted their persuasion. The death-pits multiplied.'

At each one of Hrant's disclosures, Sofi exhorted. 'But the Dolphin Children never wavered! Right?!'

The paramilitaries are surrounding the Tower. Hundreds of them. That's the odds they favour – especially when their quarry is one person.

Hrant concurred. 'Naturally they never wavered! But worse was to come. We, Leviathans, could see a new and an inordinately calamitous species of Saviours looming in the future: Saviours with neither brains nor persuasion.

And we urged the Dolphin Children to warn humanity that if it wanted survival both for itself and the planet, it should not wait for the Saviours to wane. It should hasten to depose them and replace them with sages who celebrate Creation with every fibre of their beings.

But, alas, few heeded the warning.

Thenceforth, as we had foreseen, the new species of Saviours –those with neither brains nor persuasion – materialised.

This time they concocted what they professed to be the 'ultimate canon'. The main tenet of this new devotion, they proclaimed, went back to the time when God, having begat the Universe, commanded the emblazonment of the firmament in glorification of His Name and Work. For this purpose stars and planets were charged to sacrifice them-selves, in rota, by immolation. To date, stars and planets have done so unfailingly. Now as our planet's turn for extinction approaches, God has demanded that earthlings, too, must sacrifice themselves in further glorification of His Name. Therefore, the Saviours decreed, the 'ultimate canon' preaches the attainment of 'hallowed death', in submission to God's Will, as humankind's sole piety.

By 'hallowed death' they mean not only death zealously embraced by the faithful in conflict, but also autos-da-fé inflicted by the faithful on infidels.

Nowadays, these new Saviours, dewlapped and testosterone-frenzied, accoutered with the aegis and armour of religious, military, financial and governmental establishments, pursue warfare, extermination and genocide as life's aspiration.

These days the only voice humanity hears is the clarion of these new Saviours: 'The shroud is our sacred vestment! Death is redemption!'

Eventually Sofi and I matured.
Hrant left in search of other Dolphin Children.
We took our regalia and went wherever we were needed.

We engaged all the people we met. We played guitars and violins, drums and wind instruments. We wore nuclear disarmament shirts, carried banners bearing the human rights charter. We offered garlands and peace pipes and prayer wheels. We served ceremonial teas and coffees. We showed them that doves with olive branches had joined our cause and were carrying it everywhere. We told them that life's only state of grace is Life. Not power and the usurpation of multitudes. Not nationalism and the subjugation of other peoples. Not wealth for the few and destitution for the rest. Not theocracies with their promises of joys in heaven and threats of punishments in hell. Not the worship of conflict! Not the sanctification of death to glorify gods, nations, races or ideologies! But love for peoples! For Earth! For all its creatures!

Many listened. Many more did not.

Then darkness fell as it always does.

Hrant had repeatedly cautioned us that death never stops stalking the Dolphin Children; that these days the new Saviours, to prove that they will rule until the end of time, just slay and slay and slay.

But Sofi and I were foolhardy as youngsters tend to be.

We thought time was on our side and would be for quite a while.

Yesterday Sofi was killed – down in the square.
I ran away as she died.

I fled to the grotto where I would be safe.

To my surprise, I found Hrant, sitting on the ledge.

Sofi's death was imprinted on his eyes. He looked as dolorous as a dry river bed.

I screamed at him. 'It's your fault they butchered her! You shouldn't have made her a Dolphin Child!'

He shook his head. 'I didn't make her. She was born one.'

'Well, I wasn't. Her spirit made me – that's what you said!'

Hrant faced me wearily. 'And what happened to that spirit? Where has it gone?

'It died with her.'

'Does that mean you're giving up?'

'Yes!'

'I should remind you: like all slain free-souls, Dolphin Children rise from the ashes, or germinate on land, or gravitate from the sky, or are reborn in the seas. And they resume their labour as Leviathans.'

I shut my ears and shrieked. 'I don't believe you!'

He sighed and turned away. Transmuting back into a sea-mist, he drifted out of the grotto.

The Saviours' paramilitaries start marching toward the Tower.

I take a last look at Istanbul.

It confirms Sofi's faith. 'Life is everlasting. Death is not.'

I feel aglow.

As Hrant glided out of the grotto another sea-mist appeared.

When it cleared, Sofi emerged.

She looked as Hrant did when we first saw him: in blue aura and with the sun inside her.

She held my hand. 'Running away. That wasn't wise. '

'Sometimes being unwise is wise.'

'You had mastered fear.'

'It returned when they emptied their guns on you.'

'Are we to part then?'

I gazed at her for a long time.

She touched my lips. 'I'm a Leviathan now.'
I absorbed her eyes, her face, her aura. 'I know.'
She released my hand. 'Then we are to part.'
I repossessed my wisdom. 'Having found you again – no. Never!'
'I must tend to Dolphin Children.'
'We'll tend to them together. Wait for me.'

I drape the banner with the human rights charter on my shoulders.
I walk out of Galata Tower.
The Saviours' paramilitaries are ready to execute their profession of death.

Hrant once recounted the story of yet another Dolphin Child: one called Jesus whom the Romans had crucified on Golgotha but who survived the crucifixion. To his disciples' amazement, he chose to return to the Cross. One of them asked: 'Quo Vadis, master?' 'To be recrucified,' he replied. And he became a Leviathan.

I stride toward the paramilitaries.
I shout: 'Death is a lie. Love, Life is the only truth!'
They steady their guns and fire.
I am ripped to pieces.
A sea-mist descends.
A blue aura cocoons me.

It speeds me to the grotto.
Sofi is there, waiting.
I shed my sea-mist.
We swim out of the grotto.
We gambol like flying fish – this time as Leviathans.
Then as we ride the waves to seek out Dolphin Children, Hrant appears.
He looks happy, but he also has tears in his eyes. He kisses us. 'One day the world will be repaired. There will be no need for Leviathans and Dolphin Children.'

FROM SYRIA, WITH LOVE

Tammam Azzam

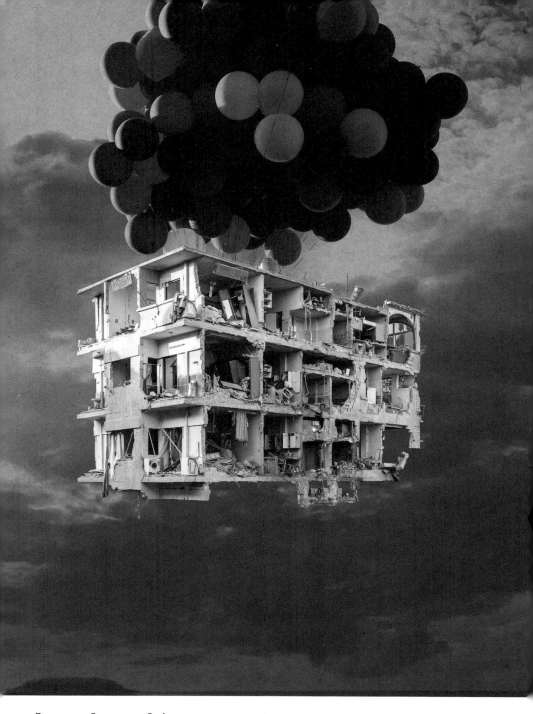

Damascus, *Bon voyage* Series

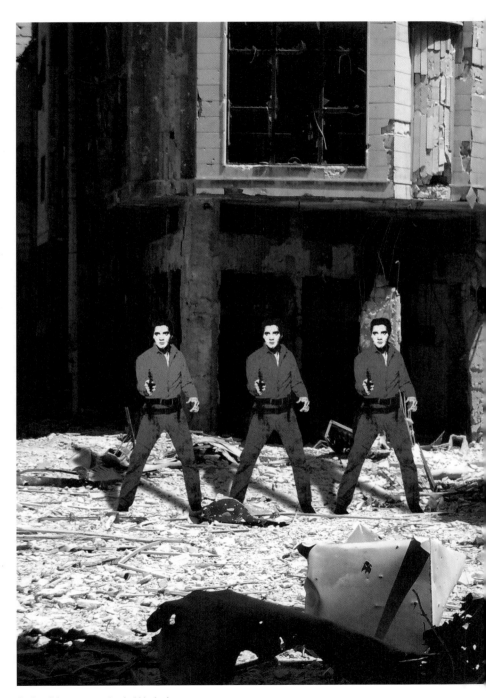

Syrian Museum — Andy Warhol

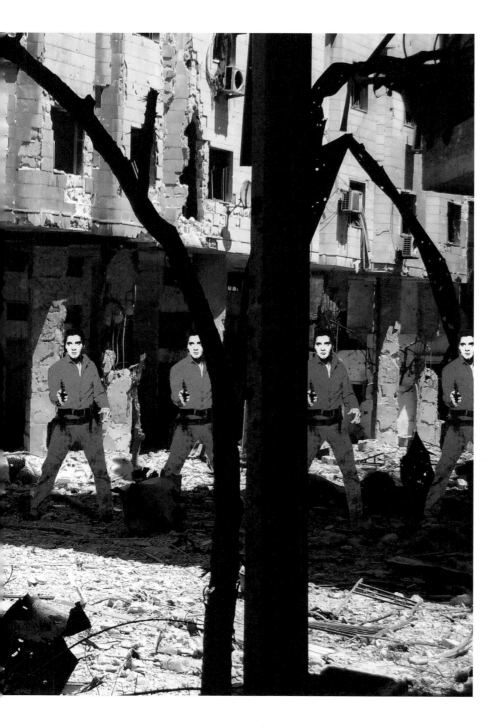

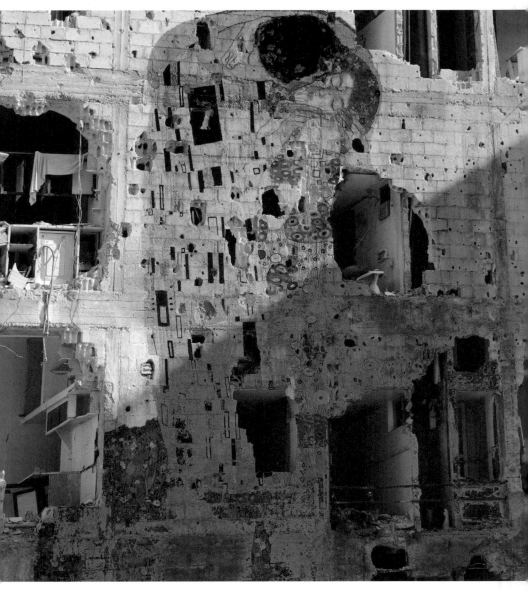

Syrian Museum
— Klimt, Freedom Graffiti

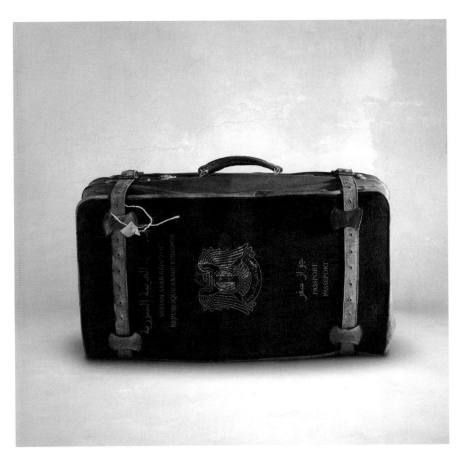

Passport

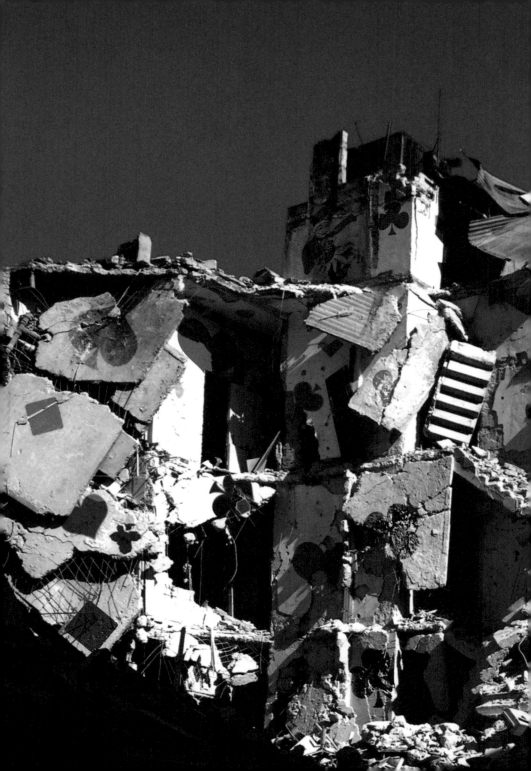

Poker

EID Bullet

SHADE-ISM

Alex Wheatle

'LATE AREN'T YOU?' barked Monica, greeting her husband at the front door with her hands on her hips, seizing him with an accusing stare. Her eyes were puffy and her voice was desperate. 'Sure you weren't giving dictation to dat Jody bitch?'

'What you chatting 'bout,' answered Horace, brushing past his wife and hanging his coat in the hallway. He knew he had been caught in a lie but wanted to act normal to refute his wife's suspicions.

'Don't fucking take me for a rarse fool, I know so you been screwing her!' Monica raised her voice, her husband's indifference fuelling her anger.

Horace, his face full of apathy, made his way to the lounge, heading for the TV. He switched it on to Sky Sports as Monica huffed in swift pursuit. He sat down on the sofa. Two carved African masks and a black-and-white monochrome painting of a slave ship were hanging on the wall, providing a backdrop for the television. Monica was proud of recognising her roots.

'You're too para, man,' Horace countered, his eyes glued on the TV. 'It's like you never forgive me for dat mistake ah couple ah year back.'

'Mistake? *Mistakes* you lying wretch. You don't remember dat red-skin bitch after Clayton's stag night?'

Horace threw his hands in the air. 'Everyone knows I was drunk up dat night. You can't include dat cos I didn't know what I was doing… And she was brown-skin – not as light-skinned as you're making out.'

'You had nuff of your senses to put your t'ing in her stinkin' pussy,' Monica replied, threateningly over her husband's shoulder.

Horace turned the volume up on the TV then wrenched off his tie. 'I don't need dis, man. Come home from work an' all you can do is go para on me 'bout some girl at work an' bring up de past. You're always striking me wid dat stick… An' where are de kids?'

Monica patrolled around the back of the cream leather sofa where her husband was sitting. Her eyes bore the evidence of bottled-up rage that she couldn't cap any longer and her breathing up-tempoed near to an asthma attack. 'Der at my Mum's. Didn't want dem witnessing dat der father t'inks more of his dick dan his family!'

Horace stood up and faced his wife over the settee. He was taken aback by his wife's fury and knew he had to calm the situation. He hadn't seen her like this before, even when his other affairs were discovered. 'Oh, for God's sake. As usual you're blowing dis up outta proportion. Me an' Jody are nutten but friends an' sometimes we go to lunch together, dat's all.'

'You mus' t'ink I'm a fucking idiot. I phoned up Darren last night, remember him, you said you was going to check him last night. You weren't fucking der, Horace. Where de fuck was you?'

'So you're checking up on me. Dat's trust for you.'

'Where de fuck were you last night?'

'I ain't taking dis. Cha! Craziness is taking you.'

Horace marched to the stairs and bounded up them, shaking his head. His steps reverberated all over the house as Monica kissed her teeth, banging her fists against the sofa. Anticipating for the truth to emerge, she slowly followed her husband to the marital bedroom. She found Horace looking through his CDs.

'Why can't you jus' admit it. When it comes to the trut' you're jus' a mouse.'

'Alright den!' Horace yelled, flinging the CDs all over the bed. 'Yeah, I did. You fucking happy now. I fucked Jody, right! Is dat what you wanted to hear?'

'You fucking dick-happy bastard.' Monica picked up one of her shoes and threw it with intent, aimed for her husband's head. 'Good was she? A few years younger dan me is she? Ain't got no stretch marks has she? You can fuck off out of de yard an' take yourself to her yard.'

Monica jumped on her husband, slapping him about the head as tears rolled down her cheeks. 'I should fuckin' bruk dat t'ing between your legs.' Horace grabbed her arms and realised the deep hurt that he had caused. Monica tried to free her wrists and lashed out with her feet, kicking Horace on the back of his head. She also managed to claw him under the chin, drawing a fine line of blood. Horace was surprised by the strength of his wife, but he was six foot plus with weight to match. He threw her off the bed where she toppled over the bedside cabinet and the clock radio that was upon it. 'Why!' she screamed. 'Why?'

Horace refused to answer and avoided looking at his wife as she composed herself, realising she was no match for a fight with her husband. She found her cigarettes and lighter on the dressing table next to a small framed photo of her and her husband on their wedding day. 'Let me guess,' she said, igniting her cancer stick, her voice falling into a sarcastic zone.

'Red-skin was she? Or a browning as you like to call them. Like de other two who I know you've cheated wid. Don't you like a black-skin girl? Don't you like your own fuckin' colour? Cos you're black like de inside of a non-stick pan, jus' like me. Why de fuck did you marry me if you wanna screw red-skin bitches all de while. Why, Horace? Makes you feel good does it? Maybe we should have decorated the house in fuckin' red, then you might feel at home, to rarted. It's like you enjoy hurting me, maybe you wanted me to find out, jus' to make me feel like shit, innit.'

Horace turned his back to his wife and looked out the window, feeling his wife's pain. He didn't mean to hurt her, he thought. He couldn't understand the reason why he craved sex with other available women. They were willing and he had accepted. Their lighter shade of brown was just a coincidence. 'I didn't do it to hurt you,' he finally replied.

'Den why, Horace? We have nice yard, an' we've never had a problem in bed. We have two nice kids. Tell me why cos I'm freaking out t'inking what I might have done wrong. An' believe, I t'ought 'bout it for hours, an' I ain't done nutten to you to deserve dis shit.'

'It's not you.'

Monica glanced across the bed, and through the mist of her cigarette smoke, noted her husband's eyes were staring at the carpet in genuine sorrow. His nineteen-inch neck was supported by a back that a cruiserweight would have been proud of. Nuff women must desire him, Monica thought. 'What d'you mean? If you had respect for me den you wouldn't screw other bitches.'

'It's nuttin to do wid you,' Horace insisted. 'I've always respected you.'

'An' dis is how you show your respect?'

'Cha! You don't understand.'

'Don't fucking understand! So I'm s'posed to understand dat you go round screwing other women. Do you know how I feel? You make me feel like I'm a wort'less woman who can't give her man what he wants.'

'I don't mean it like dat.'

'I cook you a fucking meal every day. You've always got a clean shirt in de morning an' you always come home to a clean yard. I tend to the kids every day, an' I even bring in a liccle money from my part-time job to help out. But dat ain't fucking good enough for you. *Is* it? You have to fuck about wid some bitch at work.'

Horace stretched out his hand to turn on the mini-stereo and inserted a CD. Luciano's *It's Me Again Jah* emitted from the shoebox-size speakers. A framed picture of Marcus Garvey, appearing

immensely proud in his black skin, was hanging over the top of the bed, looking down on both of them. Monica had bought it. It made her feel good to have this sort of thing around her house.

'So what?', continued Monica. 'Don't wanna hear what I have to say? Tryin' to drown me out. You ain't getting away wid dis so easy, an' you might as well pack your fuckin' bags cos you ain't staying here tonight.'

Turning off the stereo, Horace went downstairs to the kitchen. Monica abruptly killed her cigarette on the dressing table ashtray, then hounded after her husband again. She found him peering into the fridge, contemplating what to eat. 'If you t'ink I'm cooking for you again you're making a mad mistake.'

'Can't you shut de fuck up! You've made your point.'

'Shut up? You've got a fuckin' rarse cheek telling me to shut up. You should have said dat to your desires when you screwed dat Jody bitch. Does she always screw married men? Serial husband-shagger is she? Goes on like she's better dan dark-skin women does she?'

'Fuck dis,' yelled Horace, slamming the fridge door and throwing his arms up in the air. 'I'm going round my Mum's.'

'Well fuckin' mek sure you don't tek a detour to Jody's yard. Wouldn't surprise me if de bitch is in your fuckin' car, waiting for you to come out.'

'She ain't light-skin,' affirmed Horace. 'She's white!'

A festering anger that had taken residence within Monica took over all of her senses. Her breathing bordered on hyperventilation and the gums around her teeth slowly exposed themselves. Her nostrils flared as her bottom lip danced. She grabbed the bread knife that hung over the sink, which was full of unwashed cutlery. Horace saw his peril, the whites of his eyes crudely expanding, and raised his arms to defend himself. With a manic lunge, the knife missed Horace's right arm and pierced him with a crazed force under his armpit. The tip of the blade protruded out of his breast, just missing his nipple.

The look on Horace's features was of disbelief as his giant frame crashed to the floor, with his head kissing the cooker on the way down.

Inhaling almost fatally, Monica dropped the knife from her trembling hand and backed away, hypnotised by the blood that was forming a neat puddle underneath her husband's shoulder, his sky-blue shirt changing colour before her eyes. His head shook a little before this movement died and his shocked eyes closed. Monica gaped at the blood on her fingers, then her eyes moved to the black skin that covered her hand. But the only colour she saw before her was red.

COMPREHENSIVE

Tutumantu is like hopscotch, Kwani-kwani is like hide-and seek.
When my sister came back to Africa she could only speak
English. Sometimes we fought in bed because she didn't know
what I was saying. I like Africa better than England.
My mother says You will like it when we get our own house.
We talk about the things we used to do
in Africa and then we were happy.

Wayne. Fourteen. Games are for kids. I support
the National Front. Paki-bashing and pulling girls'
knickers down. Dad's got his own mini-cab. We watch
the video. I Spit on Your Grave. Brilliant
I don't suppose I'll get a job. It's all them
coming over here to work. Arsenal.

Masjid at 6 o'clock. School at 8. There was
a friendly shop selling wheat. They ground it at home
to make the evening nan. Families face Mecca.
There was much more room to play than here in London.
We played in an old village. It is empty now.
We got a plane to Heathrow. People wrote to us
that everything was easy here.

It's boring. Get engaged. Probably work in Safeway's
worst luck. I haven't lost it yet because I want
Respect. Marlon Frederic's nice but he's a bit dark.
I like madness. The lead singer's dead good.
My mum is bad with her nerves. She won't
let me do nothing. Michelle. It's just boring.

Ejaz. They put some sausages on my plate.
As I was going to put one in my mouth
A Muslim boy jumped on me and pulled.
The plate dropped on the floor and broke. He asked me in Urdu
If I was a Muslim. I said Yes. You shouldn't be eating this.
It's a pig's meat. So we became friends.

My sister went out with one. There was murder.
I'd like to be mates, but they're different from us.
Some of them wear turbans in class. You can't help
Taking the piss. I'm going in the Army.
No choice really. When I get married
I might emigrate. A girl who can cook
With long legs. Australia sounds all right.

Some of my family are named after the Moghul emperors.
Aurangzeb, Jehangir, Batur, Humayun. I was born
Thirteen years ago in Jhelum. This is a hard school.
A man came in with a milk crate. The teacher told us
To drink our milk. I didn't understand what she was saying
So I didn't go to any milk. I have hope and am ambitious.
At first I felt as if I was dreaming, but I wasn't.
Everything I saw was true.

CAROL ANN DUFFY

YESTERDAY
I STEPPED ON
A WHITE WOMAN'S
YOGA MAT

AISHA MIRZA

YESTERDAY I STEPPED ON a white woman's yoga mat by accident and she looked at me like she had woken up to me standing at the foot of her bed, like I had just suggested we murder her husband and run away together. She looked at me like I had escaped from a zoo, like I was a giant panda bear that had found its way into this sun-dappled yoga studio and was waiting casually for the 8am class to begin. She looked scared, like she had just found out that the world really *did* end in 2012, and she had been going to yoga three times a week since then for no reason because she is actually a haggard ghost. She looked at me like I do not exist in her world; but here I was, and she did not know what to do with me.

Sometimes white people look at us like they are hungry. These are the kinds of white people who might refer to us as chocolate or coffee with or without milk or Princess Jasmine. Common accompanying behaviours include trying to take selfies with us; overblown interest (especially when they find out we have heritage from Egypt or other suitably palatable brown countries their ancestors have stolen from); asking us if we speak languages we have nothing to do with; commenting obsessively on our features; and licking our faces when we are not looking.

Sometimes they look at us with grief and pity emotions, like they're watching a Unicef advert rather than a person dancing very discreetly to Moby at a bus stop. This look comes from a place of assumption, for example, 'It must be hard to be a liberated Muslim woman', and then surprise, for example, 'You are so articulate'.

Sometimes they look *through* us with a hard vacant stare after we have said something funny or clever or when we look even better than we usually do. This look is also employed when it becomes no longer convenient or comfortable or safe to be allied with us, and can be turned on very quickly and without warning. They say 'Are you OK?' when they know we are thriving.

Sometimes, after we have explained the ways in which they hurt us, white people look at us with the utmost fragility. Their eyes rattle in their sockets, saying, 'Why do you punish me for having such a big heart?'

It's funny because imagine your life being so easy that a full blown horror reaction is elicited when a brown person stands too close to your stuff even though you are a white woman doing yoga and so in fact none of this was ever your stuff at all. It's not funny because this look becomes a call to the police, becomes another brown person incarcerated in a cell or a psych ward, another black person murdered.

The look felt familiar, like an old relative I had not seen in a while and didn't want to see. When I am depressed, which is often, I watch British TV dramas with entirely white casts and feel cozy, or some fake version of that. I think about the child version of myself who did not know why I was being looked at, but knew what humiliation felt like and knew what panic felt like, and knew what it felt like to be a wild animal or a pet. Despite having received more love in my life than is reasonable, and despite being told I am beautiful,

as an instruction, from the beginning, this look is the reason I have always felt dirty or at least never quite clean. Too brown to be clean, too hairy to be clean, too gay to be clean, too Muslim to be clean, too crazy to be clean, too sensitive to be clean.

About two years ago I walked into some art event in downtown Manhattan, realised I was the only person of colour there, and immediately walked out. I guess my time being a token was over. In this city where emergency vehicles wail like mothers, like the worst has already happened, I have learned how not to live in the shadow of whiteness. I have learned that I am the sun, the object *and* the shadow. I have learned to bend over, to shake my arse, to put my fingers deep enough inside myself that at the age of twenty-seven I finally put a tampon in right. Cleanliness is overrated.

I dug my bare foot into the purple yoga mat and held her gaze.

My first panic attack was on a Northern Line tube carriage in London during the summer of 2011. I didn't know what anxiety was yet but I had it pretty bad and I'd become obsessed with the fear that I would jump in front of a train or be blown up should I successfully make it onto one. Despite having no idea how any type of bomb works, I would methodically check everyone's hands to see what they were doing whenever I got on a train or bus. This was my secret because I was ashamed that I had become the horrified white woman, but the more I tried to suppress her the more anxious I became.

I did not expect to shout at the white woman with the yoga mat because I do not shout. I cry, I stay in my bedroom for weeks, I write, I make sly remarks to people I love, I cut myself and I slap people too hard on the arm when they make me laugh, but I don't shout. Maybe I'll prove them right if I shout – 'Look, it speaks.'

It was some years later, wearing a backpack in a huge crowd of white people at a music festival that I registered a feeling of gratitude that none of them seemed frightened of me. Guilt, even, that I had put them in a situation that could be perceived as a threat. Soon after, I realised that I *am* the bomb. That I had not become the horrified white woman, but that her consistent panic, disgust and fear had engulfed me. I was seeing explosions everywhere because I was finally ready to explode.

'Listen, it was an innocent mistake', I shouted at the horrified white woman. You could also call it a generally audible remark. *Innocent. I am innocent. I have always been innocent.*

'So if you could fucking relax I would appreciate it.'

I walked away, waiting for remorse, shame or anxiety to visit, as they usually do, after any sort of confrontation I get into in white people's rooms. They did not come, and in the space they usually inhabit I felt something like peace, or it was quiet at least.

Later I ask my friends, 'Is this what it feels like to give no fucks? Has my time finally come?'

'Sweet dominion over white emotion' one replies. Another says, 'I want them to die in public. I want to kill their bigotry enough to become human.' Someone else offers, '*Namaste*, motherfucker.' We look at each other. We laugh.

At work last week my colleague pulled me aside hurriedly and said, 'I'm really trying to work through something in therapy but if I can't, I might have to drop a bomb on you later, OK?' I said 'OK' but I also could have said, 'Why do white people always want to drop bombs?' or 'Sorry, this dumping ground is full' or 'In 2017, can white women relax?'

The thing is I didn't know if I liked sleeping with white women because I'm queer or because they all

smell so good. Like if I pressed my body against theirs and breathed deeply enough, some of their clean might rub off on me. I just wanted to feel clean. I wanted to smell good. These days I mask my smell with the scent of roses and a Burberry perfume I can't afford and everyone says I smell good but I don't need to fuck white women anymore.

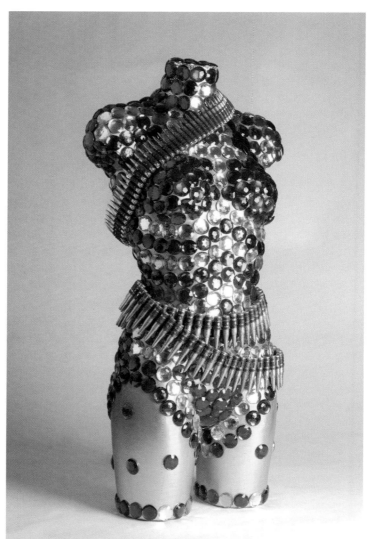

Laila Shawa
DISPOSABLE

DISPOSABLE
BODIES

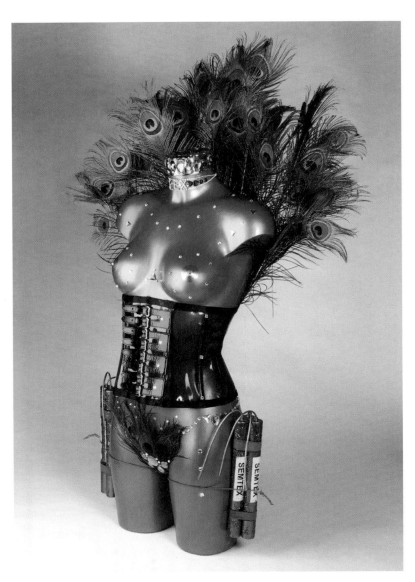

Paradise Now — Disposable Body No. 5

THE JOKE'S ON THEM

MY SEVENTEEN-YEAR-OLD SON Ounsi and I have an inside joke. Every time we use public transport in a western city, Ounsi whispers in my ear, 'Mum, what would happen if I stood up now and shouted *Allahou Akbar?*'

The first time he asked me, I think my heart stopped for a few seconds. Knowing what a wicked prankster he is, I thought he was actually going to do it. We were in the Paris metro, line four. It was rush hour and the carriage was packed with tired, fed up commuters returning from work. I immediately turned towards Ounsi and covered his mouth with both my hands. It's only then that I realised from the amused look in his eyes that he was just joking. I sighed with relief and begged him to never do that, *ever*. 'Fear has no sense of humour,' I told him before stepping down at Saint-Germain-des-Prés.

This became one of our trips' rituals; a mother and son bonding routine. Wherever we travelled, and whatever form of public transport we were using, Ounsi would wait for the most inopportune moment – when we'd literally be squeezed against other passengers – to whisper *Allahou Akbar* in my ear, while winking at me maliciously. I'd look around to make sure no one heard him, then would allow myself to laugh. With time, it took just one wink from him and I'd start giggling.

My son Ounsi and I have an inside joke. Yet if you think about it, it isn't funny at all. I shouldn't be laughing, quite the opposite. Is there anything sadder than being asked to 'Please speak in English or French, not Arabic?', which is exactly what my eldest son Mounir gently asks me to do each time I visit him in the European city where he lives and works? And Mounir isn't the paranoid type.

Whenever an Arabic word spontaneously slips out of my mouth, while my son and I are eating lunch or out shopping

perhaps, some people unmistakably stare at us in a weird way. Either ashamedly scared or hostilely angry. And I automatically, absurdly, feel compelled to stand in court and defend myself: 'We are not terrorists. We're nice people. I myself am a staunch critic of Islamic fundamentalism and have been threatened many times because of it. I can send you links if you wish...'

Obviously, this all goes on in my head. I don't say anything. I try to understand *their* perspective; that my beautiful language is linked to violence in their collective consciousness; that the words *Allahou Akbar* have become a sort of a trailer song to a horror movie and the constant prelude of a horrific, heinous crime; that we don't all have the ability to question generalisations...

But, then again, at other times, when I'm in my 'Don't you dare' mood, I look back at them defiantly, as if to say:

'Yes, I speak Arabic. Go ahead and sue me.'

'Yes, I speak Arabic and it is with this language that I have attacked fundamentalists and terrorists more vehemently than you ever will, putting my life at risk.'

'Yes, I'm from an Arab country and it is in that country that I successfully fought to publish an erotic Arabic language magazine that tackles taboos.'

'Yes, I hold an Arab passport and it is with this passport that I have travelled the world to give talks about my bestselling books.'

'Yes, I am an Arab woman and it is with this Arab female identity that I struggle to defend equality and women's rights.'

'I am an Arab woman and I am not weak, submissive or oppressed.'

'I am an Arab woman and I strive for a world where who we are is defined by what we do with our lives, the humane values that we decide to defend, the choices that we make.'

I am an Arab woman and I strive for a world where I don't have to cover my son Ounsi's mouth with my hands ever again.

JOUMANA HADDAD

MAZEN KERBAJ

COLA

We have traditions

Show what amuses you

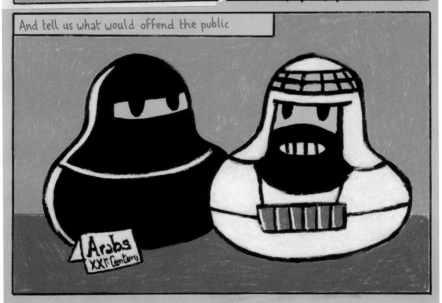

And tell us what would offend the public

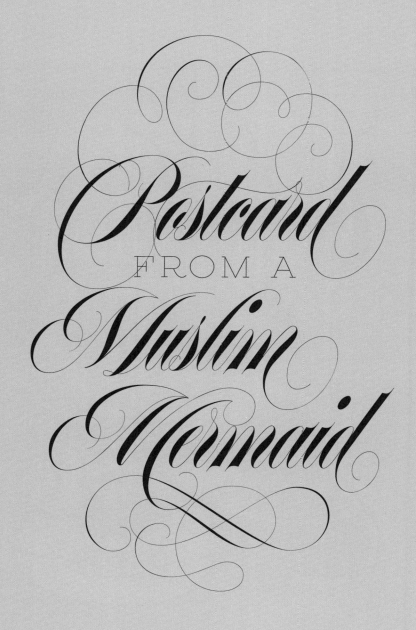

Postcard
FROM A
Muslim Mermaid

SABRINA MAHFCUZ

A poem written to be read out loud

Who, do you want, me to be?
I speak slowly, weighed down
by the rocks in my hand
I've picked up from the shore.

I am careful.
I must speak clearly,
with meaning, feeling,
there must be no misunderstanding.

I am a mermaid.
I have a rock in each hand and I'm speaking.
Who I'm speaking to is yet to be determined.
I can see the sun, it's almost blinding,
maybe that is who's listening. The sun.
Maybe that's who will give me some answers,
some clarity,
some understanding, the sun,
in a world full of misunderstanding.
This would be nice.
To have such a bright, blazing ball of support.
You see,
something's happened to me,
I must have blacked out, blanked
and when I awoke on shore,
peering inside the jelly of my mind
all I find is waves and sand and these hands,
holding these rocks and…
I am lost and I don't know where I'm from.
So, the plan is, I must keep speaking,
I must keep talking to you until the truth of me
seeps through the cracks in my words

until I've heard my life in my own voice
not in sound bites on news nights on panel shows
but here, slow, slow, slow –
I will know myself, if you will know me.

So let's start at the start.
We know I am a mermaid.
Let's start there.

A mythical creature, unable to walk,
unable to escape the ocean's walls,
unable to leave whatever surface they're laid upon –
I am a symbol of mystery, docility, duty, loyalty, danger –
is this who you want me to be?

Strangely these days I am also always white.
I am a white half human half fish.
White flesh, green or grey tail
that sparkles in the froth of clean sea.
White arms, white breasts, white neck that rises
from the depths to wave to longing men
on boats far from home.
White skin that sinks below unpolluted sea
never to be seen again until the next cartoon,
the next book, the next comic.
But they are confused.
The first version of me came from Assyria, centuries ago.
A place that now you would mostly know
as Syria, Iraq, Turkey, Iran – sound familiar?
Places where people are not thought of as white
once they are in another place proud of its own whiteness,
the kind of places that base their supposed superiority
and duty to intervene
on a mythology of racial classification
almost as ridiculous as the invention of me.

My reflection is seen only in water,
my colour dependent on the sky that day –
cloudy, clear, foggy, storm winds.
Maybe this is why I'm lost,
why I don't know who I am, where I am.
I have no real idea of my skin shade
and maybe this,
this makes me too dangerous to be given a place.
Or perhaps I am really not real at all.
Seen in the water's reflection
only through another's imagination.
But if I am, if I exist now,
with these rocks in my hand,
I will talk of the land I could have come from,
I will hope to jog some memories
as there are guards beneath the waters in front of me
and if I don't have a good story,
I've heard they won't let me swim any further,
I'll be left here in the shallows,
unable to let them know I have grown
from an acceptable area of salty H2O.

I could say:
I was born on the cusp of Iran in the Persian Gulf,
I found my way through to the hot Arabian Sea,
swam with fish like florescent confetti to Egypt's Red Sea,
admired the shimmer of pink from orange mountaintops
on top of the water which they say Moses parted
and then struggled through the Suez Canal,
emptied out as it was from non-stop ships
due to political games, rumours of it being unsafe
making it more safe for me, a mermaid,
to end up in the warm water of the Mediterranean
welcoming, I thought, but I wasn't to know
that is where the real struggles would begin.

In that comforting sea,
I somehow came to danger,
ended up in the cannibalistic canals
the rampant rivers of angry places
shivering with cold, with ice
with unknown seaweeds wrapping
their way around me until I was slime
until I was so slippery I could no longer hold onto me –
my mind hurts at this,
perhaps I will say I come from further away.
How about from beneath angry waves of the Atlantic,
rolling me back and forth
back and forth quick quick,
those swings of salt and seagulls?
And yet the Atlantic doesn't click.
Rollercoaster recollections
of spinning through tunnels of currents
past islands of magnificence that aren't mine,
I know this now I've said it out loud.

I could see it all.
Bright daylight
streaming through layers of steamy water,
couldn't avert my eyes even if I wanted to.
I wanted to.
Two came at first,
like leaves in autumn
tumbling in slow motion,
right past me.
I tried to grab under the arms of them both,
the way I'd been told to do so
if I ever saw this -
I'd never seen this,
the worst scene to see.
But the currents worked against me,

before I could dive down after them
there was four, five, six maybe ten
swirling, turning, struggling
screaming the sea into their lungs.
I was frozen.
The boat a huge cracked cloud above us
raining down humans into my hands
and I was unable to hold them,
roll them pull them save them –

is this who you want me to be?
A mermaid who makes treacherous travels a little less scary,
I will be waiting to save you and your baby.
I would like that to be me too.
But it's not.
I was floating in one spot.
I didn't move.
Just watched the sorrow of sodden souls
separate from each other,
start a new journey, alone, no help from me.
I began to swim amongst a shoal of fish
closing my eyes to it all as they did,
even as I could hear muffled anguished screams above.

So I suppose, in the end,
I can say to the guards,
it is okay, we are the same.

But then again, the more my memory returns
the more likely it seems that I might say instead:

Every area would be desolate
without the delicacies and eccentricities
that it's made up from and
by those who have passed by and who have stayed.

We have eyes and ears that see and hear
all of what you want us to be
but we still ask what that might be.
Because it seems unbelievable,
that you want us to be clever and kind
but not too clever than to be cleverer than you,
definitely not clever enough to take that job you want
and not too kind to make you look mean and greedy.
And of course you want us to be pretty,
but not too pretty not so pretty
that we might over-pretty women you need to marry
not so pretty that we might be too pretty
to want to get married, we must get married.

You want us to be covered so that we can be othered
you want us to be covered so we seem unable to choose
you want us to be naked so you can write your name upon us
you want us to have hair out so you can say see, we are free.
You want us to be unsure of our faith
you want us to be steadfast in our faith
you want us to represent the faith for the faithless
you want us to be unable to represent ourselves
you want us to represent the parts of ourselves you want
you want us all to be mermaids or war-stricken children
you want us to be myths and legends and folk tales
you want us to be National Geographic photos
you want us to be documentaries, charity campaigns
you want us to save you, save them, save ourselves.
You don't want us.
And we,
we do not need you to.

I put the stones in my hands down,
go down into the deep water,
find a coral that tells me

of a cavernous split in the seabed's belly
and I go to it, ready to find my way,
my very own way,
to a place of my own.

PREPARING MY KIDS

SAYED

I N 2014, when I moved with my family from Jerusalem to a pleasant Midwestern town, I promised myself that, come what may, I wouldn't get emotionally involved with America. As a Palestinian who'd lived for years as a minority in West Jerusalem, the city's Jewish side, I'd grown increasingly fearful for the safety of my family in Israel. I escaped to America in order to find tranquillity in a flat land, surrounded by walls of corn, soy and bitter cold, and I made a covenant that I would ignore American politics. For almost three years, I did. Driving the children to school, I preferred to listen to the chauvinistic jokes of the 'Bob & Tom Show', rather than to the morning news. I didn't want to know anything about the country in which we were only guests. I didn't read newspapers, and in the evening – unlike in Israel, where I never missed the TV news – I started to gape avidly at football games, without understanding the rules.

In recent weeks, though, like so many people in America, I have become addicted to the news. If, until a month ago, I had no desire to familiarise myself with any American politicians, now I've started to wake up from dreams in which Stephen Miller morphs into Steve Bannon as they chase leather-bound files. I get up early to see what the new president is up to, and wait in a panic to find out if he's going to sign another

executive order from his magisterial file folder. He has a long signature for a president, lots of rising and falling lines, and he often wears a fierce expression on his face, as if to let us know that life is only going to get harder.

Where in Israel I was a Palestinian, in the United States I'm a Muslim – threats are a matter of geography. But in the past couple of weeks the old, familiar fears have resurfaced. I have to admit that I had felt somewhat unhinged by the (relative) political quiet, and by the absence of the existential threat that had accompanied me all my adult life. I was afraid that the sense of security that seemed to swaddle me in America would affect the quality of my writing, that no longer being exposed to unbridled racism would leave me no choice but to launch a career as the author of romance novels for juveniles. Now I regard these feelings with a bitter irony: at long last, here comes an American president who issues boycott orders against Muslims, refugees and migrants, restoring hope and holding out promise that I will not lack subject matter for writing. At the end of the day, nothing generates creativity like a healthy sense of threat.

Still, I keep reminding myself, sometimes aloud in order to heighten my inner conviction, there's no place for comparison: America is not Israel. Here thousands have taken to the streets to demonstrate against the

KASHUA

FOR THE NEW AMERICA

anti-Muslim regulations and in favour of taking in refugees. Here more than a million marched against the president's policies on the day after his inauguration. Here there are still media outlets that don't toe the administration's line, and universities that have promised to do their utmost to protect their foreign students. But, even so, I can't help comparing the conditions in the Jerusalem I left, traumatised, almost three years ago, with what's happening here in the United States.

By the same token, I sometimes wonder how you know that the time has come to leave; after all, this isn't our war, we came here only as guests looking for peace and security for our children. I left Jerusalem utterly shorn of hope, after many years of work in the belief that ultimately we, Jews and Palestinians, would learn how to live in full equality. In Israel, I was able to read the political map from the expressions on people's faces; I learned how to sense danger from the waft of the breeze, and I could gauge the lack of hope from the colour of the trees. The United States, though, is still largely *terra incognita*, and so I don't know when I should start packing. And yet I also can't allow myself to grow complacent, given the increasing hate crimes, the assaults on Muslims, the threats to Jewish centres, and the feeling among some that they have the right to strike a posture of supremacy and thuggery against minorities. How can you be sure that when you are ready to leave it won't be too late? Following the anti-Muslim travel ban, I cancelled my participation in a writers' festival in Rome. 'You never know what else the president will decide,' my travel agent told me by way of recommendation.

In the meantime, my children insist that they're happy here, that they love their schools and their friends. After the attack on a mosque in Quebec City last month, I

decided to make sure that the instincts to recognise ethnic-based hazards, which they'd acquired in Jerusalem over the years, hadn't eroded under the disconcerting illusion of universality in the United States. I needed to know that their skills in faking an accent and adopting different religious, ethnic and national identities as necessary were still in place. We'd given them western names back in Israel, thank God.

'Listen up, kids,' I told them, as though conducting an army drill. 'When I give the signal, you start doing an American Midwestern accent.'

They sounded like locals to me. In other words, they sounded pure white to a Middle Eastern ear.

'Very good,' I said. 'And if someone should, even so, detect an accent and ask where you're from?'

'We'll tell him we're from Jerusalem,' my elder son replied. My daughter, who is the first-born child, made a face. 'Really, Dad, we've been through this a million times.' Still, I forged ahead according to protocol. 'And if it's a sharp American who knows that there's East Jerusalem and West Jerusalem, and asks which part of the city you're from?'

'We'll try to check out his politics as best we can, and then decide whether we're from the eastern or western part of the city,' my daughter said.

'Excellent. And if you discover he doesn't like either Jews or Arabs?'

'We'll say we're from Jerusalem in Yates County, New York State,' the two children replied, correctly.

My younger son didn't have to take part in the drill. He's in pre-school, speaks only English, and thinks he's as American as the next kid. He'll be fine, because we haven't yet told him that he's Muslim.

Translated from Hebrew by Ralph Mandel

One afternoon late in 1872, in a dusty room of the British Museum, a young curator who had been studying a number of cuneiform tablets shipped back by an amateur archaeologist from the recently uncovered ruins of King Ashurbanipal's library in Nineveh suddenly began to tear off his clothes and dance around the tables in an ecstasy of joy, to the restrained astonishment of his colleagues. The name of the excitable curator was George Smith and the reason for his excitement was that he had suddenly realised that he was reading the flood narrative that forms a part of the *Epic of Gilgamesh*, one of the

FABULOUS

oldest and most powerful stories we remember. Written in an Akkadian dialect from the second millennium BC, the *Epic of Gilgamesh* is the story of both a man and a city: of how a man, King Gilgamesh, came to know who he was, and of how a city, Uruk, became not only magnificent but just. Here all stories begin.

Gilgamesh is the strongest of men, 'huge, handsome, radiant, perfect,' two-thirds divine and one-third human. But Gilgamesh is also a tyrant who abuses his authority, oppressing the men and raping the women. Unable to bear his injustice any longer, the

people of Uruk call up to Heaven for reparation. The gods hear their complaint and understand that for Gilgamesh to become just, he requires a counterpart, someone who will balance the abuse of royal power so that peace will return to the city. They create Enkidu, the wild man who, as the mirror-image of Gilgamesh, is two-thirds animal and one third human. Strong but gentle, living among the beasts whom he also protects, Enkidu has no knowledge of his own humanity and natural sense of justice.

One day, a young trapper discovers Enkidu in the forest. Terrified, he tells his father that he has seen a savage creature who eats grass and drinks from the waterhole, and frees the animals from the trapper's snares so that he can catch nothing. 'Go to Uruk,' his

CREATURES

father says, 'Go to Gilgamesh,/ tell him what happened,/ then follow his advice. He will know what to do.' Gilgamesh orders the trapper to seek out the priestess Shamhat and to take her into the forest. There she is to strip naked and lie with her legs apart until Enkidu approaches. Enticed by Shamhat's charms, Enkidu will surrender. The *Epic of Gilgamesh* contains our first account of Beauty and the Beast.

Everything comes to pass as Gilgamesh has foreseen. Enkidu and Shamhat make love for seven days. Afterwards, the animals shy away from Enkidu. Having gained the beginning of self-awareness,

Enkidu has lost his animal innocence. He now knows that he is human, and the animals know it too. Dressed in one of Shamhat's robes, his hair cut, his body washed and oiled, he is taken into the city to confront Gilgamesh.

In the meantime, Gilgamesh has a dream: a star shoots across the morning sky and falls before him like a huge boulder. He tries to lift it, but it is too heavy, so he embraces and caresses it. There the dream ends. Gilgamesh's mother explains: the boulder is a dear friend, a mighty hero, whom Gilgamesh will take in his arms and caress 'the way a man caresses his wife.' 'He will be your double, your second self,' she tells him. 'May the dream come true,' Gilgamesh answers. These words are important, signaling that something in Gilgamesh, some unconscious stirring in his mind, desires the union with the other.

Enkidu challenges Gilgamesh, and the two strong men fight. At last, Gilgamesh succeeds in overthrowing Enkidu and pinning him on the ground. Then Gilgamesh fulfills his dream. He takes Enkidu in his arms and the two men embrace and kiss. 'They held hands like brothers./ They walked side by side. They became true friends.' Their adventures begin. Now that they are two, the friends can face all dangers that threaten the city-state. Fear bred from civilisation is tempered by the knowledge of the natural world and vice-versa, each man drawing strength from his own experience and intuition.

One monster that they overcome together is the Bull of Heaven, which the god Anu sends down to kill the two friends at the behest of his daughter the goddess Ishtar, whose affections Gilgamesh has spurned. The god complies with his daughter's wishes but Gilgamesh and Enkidu prove to be stronger than the beast, and kill it. Unfairly (because there is as little justice in heaven then as now) the gods decide that by killing the bull, the friends have insulted them and that one of the two heroes must die. Enkidu is chosen as the victim. But Gilgamesh will not resign himself to the loss of his beloved and, moaning 'like a dove' descends into the Underworld in an attempt to bring

Enkidu back to life. Here he speaks to the souls of the departed and is told from the lips of a Mesopotamian Noah the story of the Flood (this is the fragment first deciphered by George Smith). But now, deprived of his companion, Gilgamesh can no longer accomplish fabulous deeds. Empty-handed, he returns to his city.

The nature of the double (to give 'the other' its literary name) is ambiguous, someone identical to and yet unlike us, the image in a mirror in which left is right and right is left. The double is human and yet not entirely so; of flesh and blood but with an element of unreality because we fail to recognise or identify every one of his actions. For Gilgamesh, the double is Enkidu civilised into friendship, but he is also Enkidu the wild man, familiar with the woods and rocks. He is our neighbour, our equal, but also the foreigner, the one who does things differently, has a different colour or speaks a different language. To better differentiate us from him, we exaggerate his superficial characteristics.

The first doubles were merely monstrous: other men and women whom nature had granted different attributes from ours. The naturalist Pliny the Elder, writing in the first century AD and basing his accounts on much earlier chronicles, attributed to real people fantastical characteristics, a quality he *à priori* dismissed: 'Among these [people] are some that I do not doubt will appear fantastic and unbelievable to many. For who believed in the Ethiopians before seeing them?' Pliny lists a number of wonderful folk: the Arismaspi, 'noted for having one eye in the middle of the forehead' and for battling with griffins; the inhabitants of Abarimon 'whose have their feet turned back behind their legs [and] run with extraordinary speed'; the Albanians, who are 'bald from childhood and see more at night than during the day'; the Ophiogenes, who 'cure snake-bites by touch'; the Psylli, who 'produce in their bodies a poison deadly to snakes'; the Gymnosophists, who 'remain standing from sunrise to sunset in the burning sun... resting first on one foot and then on the other'; the Monocoli, 'who have only one leg and hop

with amazing speed' and who, when the weather is hot, 'lie on their backs stretched out on the ground and protect themselves by the shade of their feet'; the Machyles, 'who are bisexual and assume the role of either sex'.

Among the strangest of the people listed by Pliny are the Cynocephali or Dogmen, whose heads are like that of dogs and whose bodies are covered with wild beasts' skins. 'They bark instead of speaking and live by hunting and fowling, for which they use their nails.' These Dogmen (and many of Pliny's other strange folk) appear in a later chronicle of the adventures of Alexander the Great in India, a medieval best-seller known as the *Alexander Romance*, attributed to a nephew of Aristotle called Callisthenes who accompanied Alexander on his excursions. The American scholar David Gordon White noted that, with the addition of new material, 'the specific names of Alexander's monstrous enemies was revised to fit current events,' so that the 'monstrous other' would be brought up to date with each new edition. In this way, the Dogmen of the *Alexander Romance* would come to be identified, according to the various versions, with the Scythians, the Parthians, the Huns, the Alans, the Arabs, the Turks, the Mongols and a host of other real or imagined races.

In the *Epic of Gilgamesh*, this incorporation of the exotic into the familiar happens without reference to the political circumstances within which the story takes place. In later tellings, however, these circumstances become pivotal, and the story of the conflict between what is outside and what inside acquires specific historical features. Every homebred Gilgamesh requires its exotic[1] Enkidu.

All stories are our interpretation of stories: no reading is innocent. The nineteenth-century decipherers of the Nineveh tablets, George Smith and his colleagues, chose to read the *Epic of*

1 The word 'exotic' comes from the Greek, exotikos, meaning 'outside' i.e. that which is not contained within the city's walls. For centuries, in the eyes of Europeans, the idea of home, of what lies 'inside,' coincided with the idea of the West. 'Outside' was all the rest: the unfamiliar, the uncanny, the exotic Orient which lay beyond the horizon.

Gilgamesh as an endorsement of the Biblical account of Western society's beginnings. In Queen Victoria's realm, the story of a king who learns humanity from a wild other, and builds with him a powerful friendship, must have seemed almost incomprehensible. When Rudyard Kipling, in an effort to instruct his fellow Englishmen on the extent and variety of the British Empire, asked the question, 'What should they know of England who only England know?' he wasn't being merely ironical. 'Lo, all our pomp of yesterday,' Kipling warned, 'is one with Nineveh and Tyre!' -- but Gilgamesh's Nineveh was not the one in which the English chose to see their mirror. Most of Victoria's subjects endorsed a definition of England based upon the exclusion of everything and everyone 'not English.' 'Not English!' says the pompous Mr Podsnap in Dickens's *Our Mutual Friend*, whenever he doesn't understand something, and with a wave of his arm dismisses the entire world outside his little sphere of knowledge.

More than a century after the reign of Victoria, faced with a growing number of young British Muslims declaring their allegiance not to Great Britain but to the faith of Islam, Tony Blair's government decided to employ Mr Podsnap's method and, in January 2007, decreed that schools were to insist upon the notion of 'Britishness.' That is to say, instead of allowing for an Islamic perspective to become part of the multiplicity of perspectives already intrinsic to whatever 'Britishness' might mean (Saxon, Norman, French, Scots, Irish, Welsh, Protestant, etc.), the government decided to limit the concept of 'Britishness' to a quality of generalised local colour, of the kind employed in tourist propaganda. To the concept of multiculturalism, Blair's government opposed that of monoculturalism, in which all cultures are supposed to blend indiscriminately but in which practically only the dominant culture has a public voice. 'What was wrong about multiculturalism,' said Gordon Brown, using the past tense in a demonstration of wishful thinking, 'was not the recognition of diversity but that it overemphasised separateness at the cost of unity.' Brown proposed unity at the cost of multiplicity,

identifying a national 'Us' as a means not to identify with 'Them' – whoever the other might be. The point Brown missed is that it is not the 'separateness' that is detrimental to unity, but the labeling of the 'separate' others as inimical. This is the point also missed by the exclusionary policies of Donald Trump.

Coming from the other direction, the image of the West as a land of mortal danger for a Muslim casts a long shadow. In March 2007, the major Saudi newspaper, *Al-Watan*, reported that young Saudis wishing to study in the West with a government grant had to undergo an obligatory preparatory course in which they were warned against the dangers awaiting them in non-Islamic lands. Among other cautions, they were advised, when having to lodge in non-Muslim households, to 'stay away from families with daughters', 'not to remain on their own with the mother', and, if they decided to marry a foreigner, to be aware that, according to Islamic law, they would be forced eventually to divorce, 'though they were not obliged to inform their would-be spouses of this fact.' 'Such absurd arguments', says *Al-Watan*, 'stem from the conventional attitude of demonizing the other. To divide the world in 'Muslim' and 'non-Muslim' territories is in open contradiction with the reality of the modern world in which different populations mingle.'

A wiser man than Donald Trump, active in an earlier multicultural society, that of Alexandria in the third century BC, proposed a different way of considering the problem of 'separateness.' Eratosthenes of Cyrene, employed in the great Library of Alexandria, composed in his old age a philosophical treatise now unfortunately lost but of which a few fragments have been preserved in the work of later writers. One of these fragments has this to say about the notion of other: 'Towards the end of Eratosthenes's book', says Strabo, 'the author rejects the principle of a twofold division of the human race between Greeks and Barbarians, and disapproves of the advice given to Alexander, that he treat all Greeks as friends and all Barbarians as enemies. It is better, he writes, to employ as a division criteria the qualities

of virtue and dishonesty. Many Greeks are dishonest and many Barbarians enjoy a refined civilisation, such as the people of India or the Aryans, or the Romans and the Carthaginians.'

Perhaps this is one of the reasons why we are together, why Gilgamesh and Enkidu once sought one another out in a land which seems today destined to anything but togetherness, a land relentlessly drifting into a patchwork of opposing families and tribes, a land in which Enkidu repeatedly dies and Gilgamesh continues to mourn, forgetting that once upon a time they stood side by side in their adventures.

And yet, the *Epic of Gilgamesh* is not a tale of defeat. In the sequence of magical events that make up the epic adventure, Gilgamesh has acquired a deep knowledge of the meaning of death: not only that it is our unavoidable common lot, but that its communality extends to life itself; that our life is never individual but that it is endlessly enriched by the presence of the other, and consequently impoverished by the absence of the other. Alone, we have no name and no face, no one to call out to us and we have no reflection in which to recognise our features. It is only after Enkidu has died that Gilgamesh realises the extent to which his friend is part of his own identity. 'O Enkidu,' Gilgamesh weeps, 'you were the axe at my side/ in which my arm trusted, the knife in my sheath,/ the shield I carried, my glorious robe,/ the wide belt around my loins, and now/ a harsh fate has torn you from me, forever.' If the *Epic of Gilgamesh* carries a teaching, it is that the other makes our existence possible.

THERE ARE PEOPLE

CAIRO 2012

BAHIA SHEBAB

There are people who have had their head put to the ground
so that you can raise your head up high.

There are people who have been stripped naked
so you can live decently.

There are people who have lost their eyes
so you can see.

There are people who have been imprisoned
so you can live freely.

There are people who have died
so you can live.

The Muslim
A Cautionary Tale

SJÓN

O NCE THERE WAS A MUSLIM who lived in a mosque. As is his nature, the Muslim took his mosque with him wherever he went. One day the mosque with the Muslim inside fell off the back of a lorry that was transporting it to some place or another and my wife found it by the side of the road as she was coming home from work. We placed the mosque in the east-facing part of our garden because we're told that's what the Muslim prefers. Since we didn't know what the Muslim eats, we found some scraps in the fridge and lined them up in dishes by the entrance to the mosque: milk, cheese, a quarter of a cucumber, some ham, a hardboiled egg, a splash of red wine and two potatoes. Then we set out our deckchairs and waited for the Muslim to come out to feed. When midnight passed and there was still no sign of him, we went to bed.

The following day, the cucumber, half the egg and most of the wine had gone, so we refilled the dishes before going to work. My wife works in an office while I have a study upstairs in our house. Every now and then I took a break from my tasks to peer out of the window and see if the Muslim was up and about. When nothing had happened by two in the afternoon, I went outside and tiptoed down the garden to the mosque. I listened intently, holding my breath, and was rewarded by the sound of the Muslim stirring inside. He was moving very slowly – the sound was like the rustle of dry leaves drifting along a sundeck in a gentle breeze

– and I wondered if he was listening to me and waiting for me to leave. Stealthily, I backed away until I was hidden behind a currant bush from where I could keep an eye on the mosque through the branches.

All this creeping about had brought me out in a sweat. Closing my eyes, I wiped my damp forehead and face with the flat of my hand. When I opened them again, a moment later, the mosque had vanished. Search though I might, I couldn't find it anywhere. I knocked on our neighbour's door and she told me that this was only natural: the Muslim often travels south without warning, following his instinct. She asked if we'd had the Muslim vaccinated when we got him. I explained that he and his mosque had been in our garden less than twenty-four hours; my wife had only found him the previous day. On hearing this, the neighbour said coldly that in that case I could forget about seeing him again: the Muslim who hasn't had his shots is invariably denied entry to the country on his return from journeying south with his mosque.

My wife was upset to hear the news when she came home from work. Together we drove around until late in the evening, scouring the neighbourhood in vain for the Muslim and his mosque. I was too wound up to sleep, if I'm honest, and it took all my wife's efforts to calm me down. After she'd given me a glass of warm milk with honey and we had talked it over at the kitchen table, we agreed that it was probably best for all concerned that the Muslim had disappeared. In our delight at finding him we had forgotten that he is apt to sing at all hours of the day and night until his whole mosque resounds. We couldn't have subjected ourselves or our neighbours to that.

That night more food was taken from the dishes in our garden. I had forgotten to bring them inside.

Translated from Icelandic by Victoria Cribb

AFTER-WORD

LYNN GASPARD

For the last thirty years, Saqi has been an independent forum for writers and artists from all places and cultures, releasing seminal works about the Middle East, North Africa and beyond. In early 2017, at a time when the world was seeing a rise in extremist ideologies and identity politics, in the fear of the 'other' and the demonisation of minorities, we were so dismayed by the latest ill-thought-out government policy, this time directed at residents of seven predominantly Muslim countries, that we felt we had to respond.

The writing and art in *Don't Panic, I'm Islamic* subvert stereotypes propagated by reactionary voices in both the East and West. From the Muslim boy who dreams of becoming a drag queen, to the black gay woman finding a place for herself in New York and to the fearless human rights activists facing imprisonment or worse in Istanbul, this book is a powerful rebuttal to those who try to repress our individuality and personal freedoms, be it because of our religion, sexuality, colour or politics. Provocative, fierce and

at times laugh-out-loud funny, it offers space to the contributors' individual expressions, many of which are not usually heard in the mainstream.

Escaping the war in Lebanon, Saqi's founders yearned to recreate something of the heady intellectual freedom of pre-war Beirut. The devastation of that civil war propelled them to publish writing and art that would enlighten and challenge. Saqi has released works by cutting edge and authoritative voices – including works by Muslim feminists, Jews, Christians, Kurds and other minorities in the Middle East, works often banned in their original countries – all of which has helped form a clearer picture of these mis- or under-represented communities.

Where war or repression attempt to stifle creativity, the opposite can also be achieved. A steely resolve rises to give voices to the suffocated. And the more diverse these voices are, the harder it is to silence or restrict them.

I would like to thank the thirty-four contributors whose work has stunned and humbled me; the translators who worked to an impossibly tight deadline; my awe-inspiring colleagues at Saqi, Elizabeth Briggs and Enyseh Teimory; Jo Glanville and everyone at English PEN; Samuel Shimon and Margaret O'Bank at Banipal; Amani Hassan and Nadia El-Sebai at the Arab British Centre; Rukhsana Yasmin; and last but not least, my comrade, Jayyab Abusafia.

ABOUT THE CONTRIBUTORS

HASSAN ABDULRAZZAK is a British Iraqi playwright living in London. His previous plays include *Baghdad Wedding* (Soho Theatre, 2007), *The Prophet* (Gate theatre, 2012) and *Love, Bombs and Apples* (Arcola Theatre, 2016). His new play *And Here I Am* will be part of the Shubbak Festival 2017 and will then tour the UK. His essays, short stories, translations and poems have appeared in *The Guardian*, *Edinburgh Review*, *Banipal* and *Snakeskin*. He is the recipient of George Devine, Meyer-Whitworth and Pearson theatre awards as well as the Arab British Centre Award for Culture.

LEILA ABOULELA was the first winner of the Caine Prize for African Writing. She is the author of four novels, *The Kindness of Enemies*, *The Translator*, a *New York Times* 100 Notable Books of the Year, *Minaret* and *Lyrics Alley*, Fiction Winner of the Scottish Book Awards. Her collection of short stories *Coloured Lights* was shortlisted for the MacMillan Silver PEN Award. Leila's work has been translated into fourteen languages, broadcast on BBC Radio and appeared in publications such as *Granta*, *Freeman's* and *The*

Guardian. Leila grew up in Sudan and moved to Scotland in her mid-twenties.

CHANT AVEDISSIAN was born in Cairo. He studied fine arts in Montreal and print-making at the Ecole National Superieure des Arts Decoratifs, Paris. He returned to Cairo in 1980 and worked with Hassan Fathy from 1981–89. His work is part of the public collection at the British Museum, the Smithsonian Institution, the Tropenmuseum (Amsterdam), the National Museum of Scotland and the National Gallery of Jordan. His publications include *Cairo Stencils* and *Patterns, Costumes & Stencils*. He lives in Cairo.

Born in Damascus, TAMMAM AZZAM currently lives in Germany. Originally trained in Fine Art, Azzam turned to digital media and graphic art following the outbreak of violence in Syria to create visual composites of the conflict that would resonate with an international audience. In 2013, Azzam made headlines worldwide when his Freedom Graffiti print went viral. He has participated in solo and group exhibitions at galleries and institutions worldwide including City Museum of Odenburg in Germany, For-Site Foundation in San Francisco, Banksy's Dismaland in Weston-super-Mare, Fondazione Giorgio Cini in Venice, De Tolhuistuin in Amsterdam, Rush Arts in New York, Abu Dhabi Festival and Ayyam Gallery in London and Dubai.

BIDISHA is a journalist and broadcaster specialising in social justice, international affairs, gender and the arts. In 2013 she was an International Reporting Project Fellow, raising awareness of global health and development issues. She also does outreach work in UK prisons, detention centres and refugees' resource centres. This inspired her fifth book, *Asylum and Exile: Hidden Voices of London* (2015). Bidisha was the regular presenter of BBC Radio 3's flagship arts programme *Night Waves* and the World Service arts show *The Strand*, as well as guest presenting Radio 4's *Saturday Review* and *Woman's Hour*, for which she is also a regular

contributor. She is a Trustee of the Booker Prize Foundation and is also a published poet.

CHAZA CHARAFEDDINE is a Lebanese artist, photographer and writer. Her 'Divine Comedy' series mixes her photographic portraits of men with 1940s Iranian, Indian, Afghani and Egyptian popular portrayals of mythological beings or with Mughal Islamic art from Persian and Turkish miniatures of the fifteenth to the eighteenth centuries. Charafeddine's work has been exhibited worldwide including at the Institut du Monde Arabe in France, Högkvarteret Gallery in Stockholm and Green Art Gallery in Dubai; and her performances have been shown in contemporary art venues in Lebanon and Europe. Chaza Charafeddine is represented by Agial Art Gallery / Saleh Barakat Gallery, Beirut.

MOLLY CRABAPPLE is an artist, journalist, and author of the memoir, *Drawing Blood*. Called 'an emblem of the way art can break out of the gilded gallery' by *New Republic*, she has drawn in and reported from Guantanamo Bay, Abu Dhabi's migrant labour camps, and in Syria, Lebanon, Gaza, the West Bank and Iraqi Kurdistan. Crabapple is a contributing editor for *VICE*, and has written for publications including the *New York Times*, *Paris Review* and *Vanity Fair*. Her work is in the permanent collection of the Museum of Modern Art.

CAROL ANN DUFFY DBE is a Scottish poet and playwright. She is the first woman, the first Scot and the first openly LGBT person to hold the position. She was appointed Britain's Poet Laureate in 2009 for a fixed ten-year term. Among her most notable collections of poetry are *Standing Female Nude* (1985), winner of a Scottish Arts Council Award; *Selling Manhattan* (1987), which won a Somerset Maugham Award; *Mean Time* (1993), which won the Whitbread Poetry Award; and *Rapture* (2005), winner of the TS Eliot Prize.

MORIS FARHI MBE is an Anglo-Turkish author. He is a Fellow of the Royal Society of Literature and a Vice-President of International Pen. He trained at the Royal Academy of Dramatic Art and after a brief acting career turned to writing. His award-wining works include the novels *Journey through the Wilderness*, *Children of the Rainbow*, *Young Turk* and *A Designated Man*, and a collection of poems, *Songs from Two Continents*.

NEGIN FARSAD is an Iranian-American comedian, actor, writer and filmmaker based in New York. Like most comedians, she has a master's degree in African-American studies. She was named one of the 53 Funniest Women by the *Huffington Post*, one of '10 Feminist Comedians to Watch' by *Paper* magazine, and was selected as a TED Fellow for her work in social justice comedy. She is host of the Fake the Nation podcast and has written for/appeared on Comedy Central, MTV, PBS, IFC, Nickelodeon among others. She is director/producer of the feature films *The Muslims Are Coming!* starring Jon Stewart, David Cross and Lewis Black (available on Netflix) and *3rd Street Blackout*, starring Janeane Garofalo and Ed Weeks.

JOUMANA HADDAD is an award-winning writer, journalist and women's rights activist. She was selected as one of the world's 100 most powerful Arab women for four years in a row by Arabian Business magazine for her cultural and social activism. She is the founder of Jasad, a quarterly Arabic-language erotic cultural magazine, which made headlines around the world at its launch in 2009. Her publications include *I Killed Scheherazade: Confessions of an Angry Arab Woman*, which was translated into thirteen languages, *Superman is an Arab: On God, Marriage, Macho Men and Other Disastrous Inventions*, and *The Third Sex*. She lives in Beirut with her two sons.

SALEEM HADDAD was born in Kuwait City to an Iraqi-German mother and a Palestinian-Lebanese father. He has worked with Médecins Sans Frontières and other international

organisations in Yemen, Syria, Iraq, Libya, Lebanon, and Egypt. His debut novel *Guapa* was published in 2016, receiving critical acclaim from the *New Yorker*, *The Guardian* and others, and was awarded a Stonewall Honour in 2017. Haddad was selected as one of the top 100 Global Thinkers of 2016 by *Foreign Policy* magazine. His writing has appeared in *Slate*, the *Los Angeles Review of Books* and *The Daily Beast*, among others. He currently divides his time between London and the Middle East.

British Moroccan artist HASSAN HAJJAJ has established an international following for his photography. His work features in several collections worldwide, including the Victoria & Albert Museum, London, the Los Angeles Museum of Contemporary Art, Los Angeles; the Brooklyn Museum, New York; and Institut des Cultures d'Islam, Paris. Hajjaj's most recent solo shows include 'My Rock Stars' at the Newark Museum, USA (2015) and 'Kesh Angels', Taymour Grahne Gallery, New York (2014). Hajjaj won the Sovereign Art Foundation Middle East and African Art Prize 2011 and was shortlisted for the Jameel Prize 2009 at the Victoria & Albert Museum, London. His work has featured in numerous publications, including *Hassan Hajjaj: Photography, Fashion, Film, Design*.

OMAR HAMDI is a Welsh-Egyptian TV presenter, comedian and writer. He grew up in Cardiff before moving to London to perform stand-up full-time. He has completed a national UK theatre tour, as well as performing at various festivals and clubs around the world. His work and TV programmes have been well-received and won a BAFTA among other awards. He has been recommended by the National Union of Journalists as 'a talented comic commentator on topical events', and by the *Telegraph* for his 'shrewd insights into multiculturalism'. His writing has been published in the *Independent*, *International Business Times* and *New Internationalist*.

JENNIFER JAJEH is a Palestinian-American actress, writer and comedian whose work lies at the intersection of global politics, identity and pop culture. Her critically acclaimed one woman show *I Heart Hamas: And Other Things I'm Afraid to Tell You* toured for five years across the US and internationally. Directed by W. Kamau Bell, the show was dubbed 'a fantastic and important piece of theatre' at the Edinburgh Fringe where it received a slew of 5 star reviews. Jajeh can currently be seen on stages across Los Angeles honing her unique brand of political comedy and storytelling. She will make her television debut on the Emmy award-winning show *Transparent* in autumn 2017.

AMROU AL-KADHI is a British-Iraqi writer, performer, filmmaker and drag queen. Whilst studying at Cambridge he set up musical comedy drag troupe Denim, which has since performed to diverse audiences around the UK, including at Edinburgh Festival 2017 and with Florence and the Machine at Glastonbury. Amrou wrote and starred in the short film *Nightstand*, which was executively produced by Stephen Fry and distributed to seventy-two cinemas nationwide. He is currently co-writing a comedy TV series entitled *Nefertiti* that he will also star in and which is in development with Big Talk Productions and Channel 4. He is also working on the feature film *Abigail* and Gabriel with Sarah Brocklehurst Productions and BBC Films.

SAYED KASHUA is the author of the novels *Dancing Arabs*, *Let It Be Morning*, shortlisted for the International IMPAC Dublin Literary Award, and *Exposure*, winner of the prestigious Bernstein Prize, and the autobiographical collection, *Native: Dispatches from a Palestinian-Israeli Life*. He is a columnist for *Haaretz* and the creator of the popular, prize-winning sitcom *Arab Labor*. Kashua has received numerous awards for his journalism including the Lessing Prize for Critic (Germany) and the SFJFF Freedom of Expression Award (USA). Now living in the United States with his family, he teaches at the University of Illinois.

MAZEN KERBAJ is a Lebanese graphic novelist, visual artist and musician. The author of over fifteen books, his work has been published in a number of international anthologies, newspapers and magazines and translated into more than ten languages. His art has exhibited in galleries, museums and art fairs worldwide. Kerbaj is considered to be one of the initiators and key players of the Lebanese free improvisation and experimental music scene. He is co-founder of Irtijal, an annual improvisation music festival, and of Al Maslakh, the first experimental music label in the region. A trumpet player, Kerbaj has played in solo and group performances around the world since 2000.

ARWA MAHDAWI is a British-Palestinian writer based in New York. Arwa started her working life as a corporate lawyer but after getting stuck on a seventeen-year-old case about ice-cream she had a minor meltdown and switched to advertising. Having acquired a Green Card (through entirely legitimate means), Arwa promptly quit advertising for the lucrative field of freelance journalism and is now a frequent contributor to *The Guardian*. Her side hustle is Rent-a-Minority: a revolutionary service that lets corporations rent minorities on-demand. Sometimes described as an 'Uber' for diversity, Rent-a-Minority is great for those embarrassing moments where you realise your award show/ corporate brochure/ conference panel is entirely composed of white men yet again!

SABRINA MAHFOUZ is a British Egyptian playwright, poet and screenwriter. She was awarded the Fringe First Award for her play *Chef*, and her play *Clean* transferred to New York in 2014. Her poetry has been performed and produced for TV, radio and film, including in the recent *Railway Nation: A Journey in Verse* on BBC2. Mahfouz is the editor of *The Things I Would Tell You: British Muslim Women Write*, has an essay in the award-winning *The Good Immigrant*, and has published eight plays with Bloomsbury Methuen. *How You Might Know Me* is her debut collection of poetry with Out-Spoken Press.

ALBERTO MANGUEL is internationally acclaimed as an anthologist, translator, essayist, novelist and editor, and is the author of several award-winning books including *A Dictionary of Imaginary Places*, *A History of Reading* and *The Library at Night*, and the novels *News from a Foreign Country Came* and *All Men Are Liars*. He was born in Buenos Aires and became a Canadian citizen in 1982. Manguel was named a Commander of the Order of Arts and Letters in France, and is currently the director of the National Library of Argentina.

ESTHER MANITO is a British Lebanese comedian. Listed as 'One to watch' in 2016 by Funny Women, the UK's Leading Female Comedy Community, she was also a semi-finalist in the Leicester Square Comedian of the Year competition in the same year. Esther has appeared on BBC Radio 4 Extra as part of the new comedy awards and will be performing her first show at the Edinburgh festival in August 2017.

AISHA MIRZA is a writer, artist and counsellor from East London, currently living in Brooklyn, New York. She studies the impact of microaggressions on the psyche of queer black and brown people, and is interested in body hair, madness and race. Aisha's written work has appeared in *The Guardian*, *Independent*, *Black Girl Dangerous*, *Media Diversified* and openDemocracy, and she was one of the contributors to the anthology, *The Things I Would Tell You: British Muslim Women Write*, published in 2017. She has shown art in London and New York.

JAMES NUNN is an artist, book designer and illustrator whose recent work includes *The Corbyn Colouring Book*, *Colouring the Tour de France*, and *At Night: A Guide for the Wakeful*. He was born in Bradford during the three-day week and has never looked forward. Amidst the regular power cuts of the 1970s he learnt to draw entirely in the dark. He drew the panda on the bestselling guide to punctuation, Eats, Shoots and Leaves. He lives and works in Bath.

CHRIS RIDDELL is a British author, illustrator and renowned political cartoonist whose work appears in *The Observer*, *Literary Review* and *New Statesman*. He is the creator of an extraordinary range of books which have won many illustration awards, including the UNESCO Prize, the Greenaway Medal and the Hay Festival Medal for Illustration. Riddell also achieved global success through his *New York Times* bestselling collaboration on *The Edge Chronicles* with Paul Stewart and through his illustrated works with other high-profile figures including Neil Gaiman. He was appointed UK Waterstones Children's Laureate 2015–17. He lives and works in Brighton.

HAZEM SAGHIEH is a Lebanese writer and journalist. He is the editor of the daily *Afkar* (Ideas) page for *al-Hayat* newspaper and the political weekly supplement *Tayyarat* (Currents). Saghieh has published numerous books in Arabic, including works on Umm Kulthum, Arabism and the cultures of Khomeinism. He lives in Beirut.

RANA SALAM has been running her Beirut-based design studio for over a decade. She specialises in brand creation, art direction and consultancy, and event curation, and has produced distinctive designs for clients as diverse as Harvey Nichols, Villa Moda, Liberty of London, Boutique 1, the Victoria & Albert Museum and Paul Smith. A graduate of Central St Martins and the Royal College of Art, Salam is among the most celebrated of designers and is known for her understanding and use of Middle Eastern popular art and culture. Her work has been widely published in magazines including *Elle Deco*, *Wallpaper*, *Creative Review*, *Design Week*, *Aishti*, *Bespoke*, *Canvas* and *Brownbook*.

KARL SHARRO is an architect, satirist and commentator on the Middle East. He blogs at Karl reMarks and has written for a number of international publications including *The Atlantic* and *Los Angeles Review of Books*. He wrote and presented a short video, 'Simple one-sentence explanation for what caused ISIS', for

Channel 4 in 2015. Taking part in several BBC broadcasts, Sharro's idea for a '1000 Mile-City' along the East Mediterranean coast was broadcast on the BBC's This Week's World. His publications include *Style: In Defence of Islamic Architecture* and co-author of *Manifesto: Towards a New Humanism in Architecture*.

LAILA SHAWA is a Palestinian artist living in London. Her work has been exhibited and is held in public and private collections worldwide, including the national galleries of Jordan and Malaysia, the Ashmolean Museum in Oxford, the British Museum in London and the National Museum for Women in the Arts, Washington DC. Her most recent works *Trapped* and *The Other Side of Paradise* were exhibited at the October Gallery in London in 2012.

BAHIA SHEHAB is an award-winning artist, art historian and scholar of Arabic script based in Cairo. Her street art has been on display in museums, galleries and streets around the world, and was featured in the 2015 documentary *Nefertiti's Daughters*. She is the recipient of many awards and international recognitions, including the UNESCO-Sharjah Prize for Arab Culture (2017), Prince Claus Fund Award (2016), TED Senior fellowship (2016) and BBC 100 Women list (2014). Shehab is associate professor of design and founder of the graphic design program at the American University in Cairo. Her publications include *A Thousand Times NO: The Visual History of Lam-Alif*.

Born in Reykjavik in 1962, SJÓN is a celebrated Icelandic novelist. He won the Nordic Council's Literary Prize for *The Blue Fox* (the Nordic countries' equivalent of the Man Booker Prize) and *From the Mouth of the Whale* was shortlisted for the International IMPAC Dublin Literary Award and the Independent Foreign Fiction Prize. His latest novel *Moonstone – The Boy Who Never Was* was awarded the 2013 Icelandic Literary Prize. Also a poet, librettist and lyricist, Sjón has written nine poetry collections, four opera librettos and lyrics for various artists. In 2001 he was

nominated for an Oscar for his lyrics in the film *Dancer in the Dark*. Sjón's novels have been published in thirty-five languages.

ELI VALLEY is a writer and artist whose work has been featured in *The New Republic, The Nation, The Nib, The Village Voice, Daily Beast, Gawker, Current Affairs* and elsewhere. His art has been labelled 'ferociously repugnant' by *Commentary* and 'hilarious' by *The Comics Journal*. The 2011–13 Artist in Residence at the *Forward* newspaper, he has given multimedia performances fusing comics with personal narrative in the United States, Europe, Africa and Israel. His first comics collection *Diaspora Boy: Comics on Crisis in America and Israel* was published in 2017.

Born to Jamaican parents living in Brixton, ALEX WHEATLE MBE spent most of his childhood in a Surrey children's home. In 1977 he returned to Brixton and founded the Crucial Rocker sound system, performing his own lyrics under the name of Yardman Irie. He spent a short stint in prison following the 1981 Brixton uprising. After his release he became known as the Brixtonbard, and his first novel *Brixton Rock* was published to critical acclaim in 1999. Alex is now working on the next title in his *Crongton* series. He teaches in various places and holds workshops in prisons. In 2008 Alex was awarded an MBE in the Queen's Birthday Honours list for services to literature.

SHADI ALZAQZOUQ is an award-winning Palestinian artist whose works have been exhibited in solo and group shows around the world. In his series Muslim Punk, Alzaqzouq combines universally-recognised though traditionally contrary punk and Muslim characteristics to create one being. In this way, the being disturbs the establishment while also highlighting the freedom of each individual and their religion. Currently residing in Paris where he graduated in Fine Art from Paris 8 University, Alzaqzouq was invited by the renowned street-artist Banksy to participate in his show Dismaland in 2015. He won the Qattan Foundation Young Palestinian Artist Award in 2007.

PERMISSIONS

LEILA ABOULELA, 'Majed', originally published in *Coloured Lights* (Polygon, 2001).

CHANT AVEDISSIAN, 'Haya Natakalam – to learn Latin letters' and 'Barlon Ansambel – to learn Arabic letters', Private collection of the artist, Cairo.

CHAZA CHARAFEDDINE, 'Who Took My Lipstick?, Dame Aux Fruits, Sultane,' © Chaza Charafeddine and Agial & Saleh Barakat Gallery.

> 'Who Took My Lipstick?' Background: different plates from the Mirâj Nâmeh depicting the gardens of Paradise. Produced in the fifteenth century by several artists of the illumination workshops of Herât in Khurasan. Technique: photography, printed on fine art paper, 27 × 42.3 cm.

> 'Dame Aux Fruits' Background: calligraphy panel at the entrance of Wazir Khan Mosque in Lahor, Pakistan. Technique: photography, printed on fine art paper, 100 × 99cm.

> 'Sultane' Background: Portrait of Sultan Abdul-Hamid II and Sultan Mahmud II of the Ottoman Empire. Technique: Photography, printed on fine art paper, 100 × 75.28cm.

CAROL ANN DUFFY, 'Comprehensive' from *Standing Female Nude* (Anvil Press Poetry, 1985). Copyright © Carol Ann Duffy. Reproduced by permission of the author c/o Rogers, Coleridge & White Ltd., 20 Powis Mews, London W11 1JN.

MORIS FARHI, *Of Dolphin Children and Leviathans*, first published in *Une Enfance Turque* (2015) by Bleu-Autour; reissued as *Un Jour Le Monde Sera Reparé*. © Moris Farhi.

Published 2017 by Saqi Books

Book design by Will Brady

ISBN 978-0-86356-999-9
eISBN 978-0-86356-993-7

A full CIP record for this book is available from the British Library.

Printed by PBtisk a.s.

Saqi Books
26 Westbourne Grove
London W2 5RH
www.saqibooks.com

The Arab British Centre